WOOF

A book of happiness for dog lovers

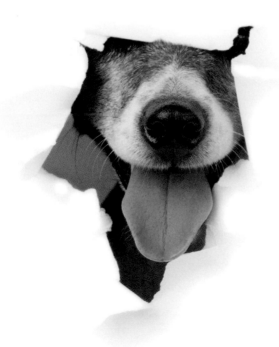

PUBLISHING

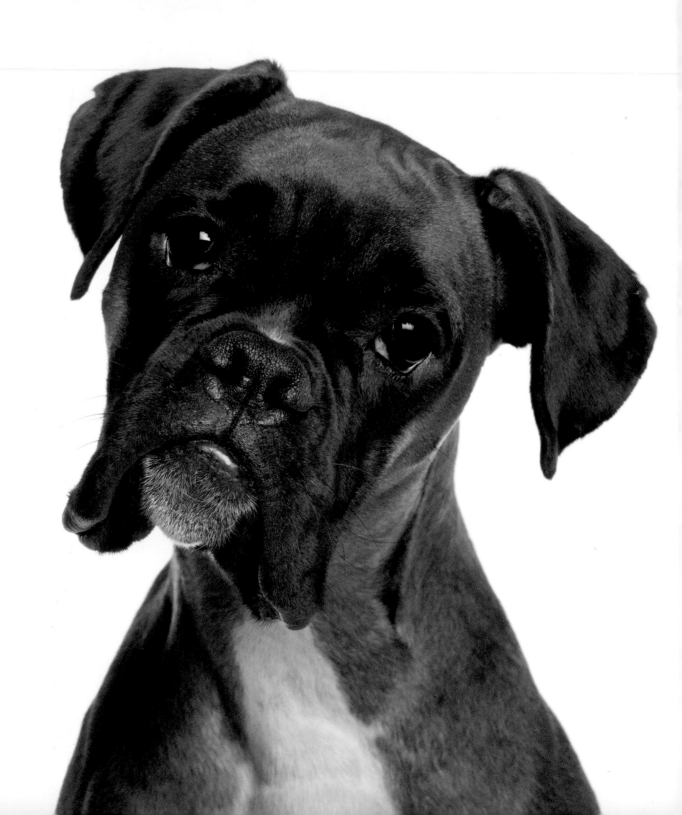

Introduction

Dogs. What would our lives be without them? In good times, there is no other animal that can share in our happiness with such pure nose-to-tail enthusiasm. In sad times, there is no other animal that can convey such compassion and love with the mere touch of a concerned paw.

Dogs give themselves to us completely. Whether a lapdog in an apartment or a working dog on a farm, every dog seeks only to be with us and to please us. All they ask in return is our love and loyalty. Whether a child's best friend, privy to secrets that no human is worthy of, or keeping pace with an elderly owner on the daily walk, dogs add richness and companionship to our lives.

We might have to deal with muddy paw prints, messy eating habits or shedding coats. We might come home to ripped cushions, chewed shoes and dug-up pot plants. We might have a dog that puts Houdini to shame with their escape-artist tendencies. But all of that fades into insignificance when we look into those warm eyes and see that wagging tail!

Dogs have inspired memorable quotes across the centuries. Mark Twain, Kafka, Nietzsche, Woodrow Wilson, Aldous Huxley and Charles Dickens are just a few of the famous names who've been inspired to comment on our canine companions. But the quotes collected here are not all by famous people, nor are they all deep and meaningful. Some simply capture that playful sense of fun which so many dogs have mastered.

The result is a book that can be dipped into or read from cover to cover. Much like your dog, its intention is to bring you both happiness and comfort.

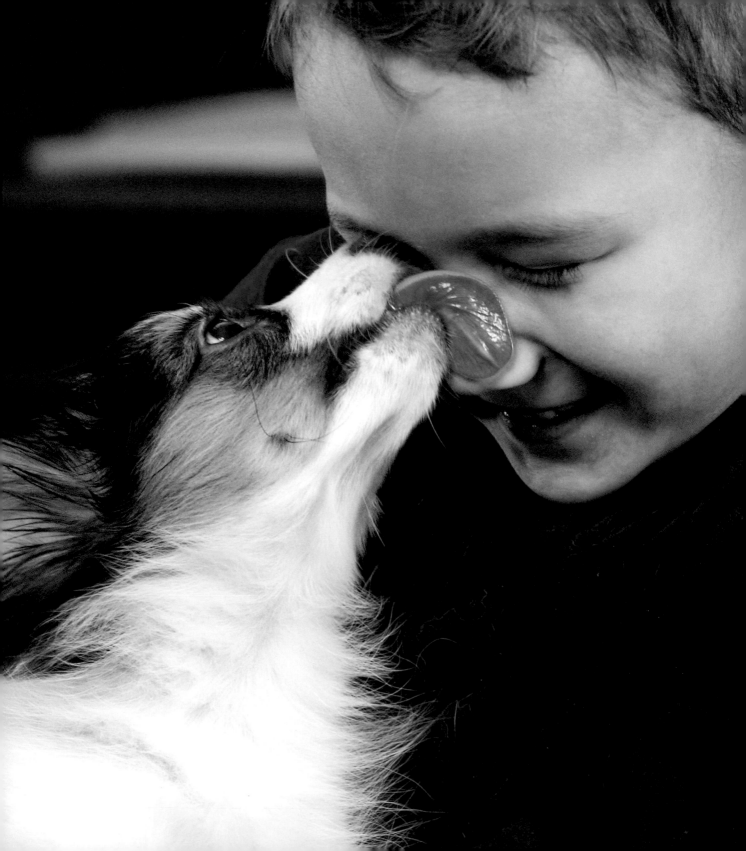

There is no psychiatrist in the
world like a puppy licking your face.

BEN WILLIAMS

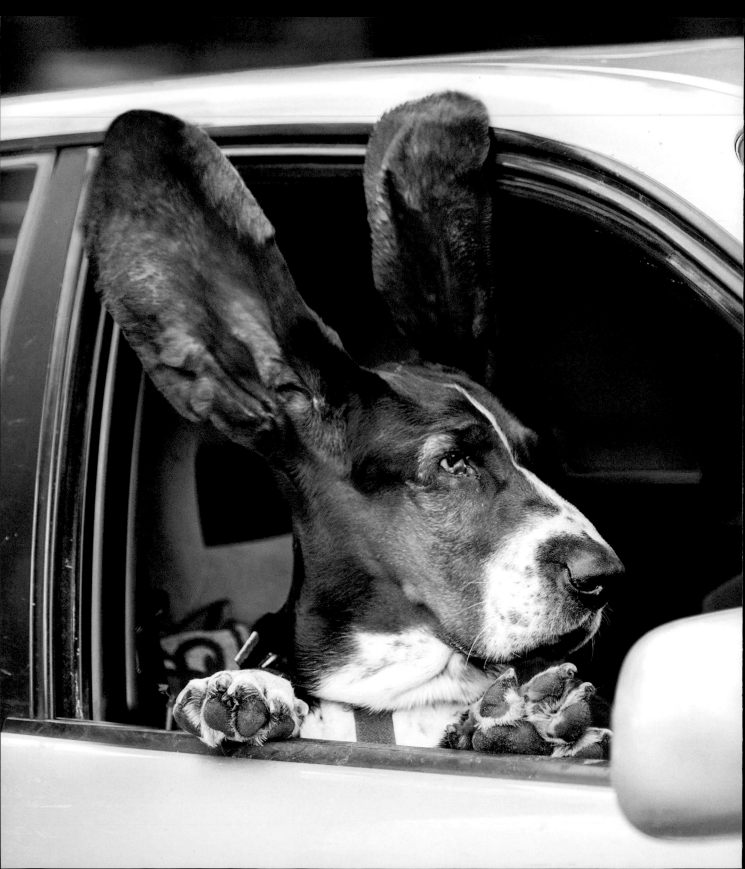

The great pleasure of a dog is that you may make a fool of yourself with him and not only will he not scold you, but he will make a fool of himself too.

SAMUEL BUTLER

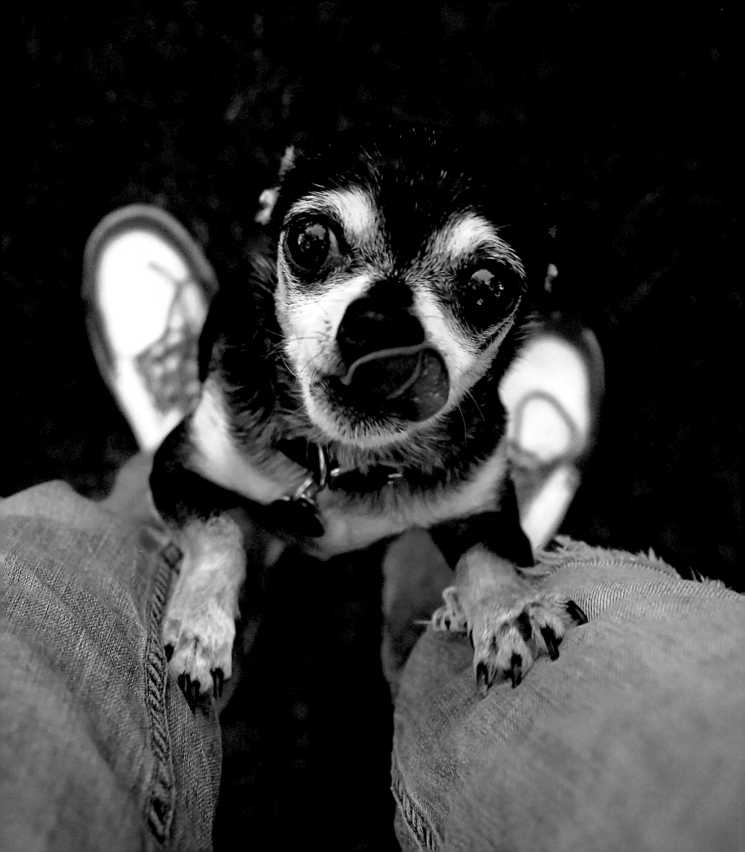

My little dog — a heartbeat
at my feet.

EDITH WHARTON

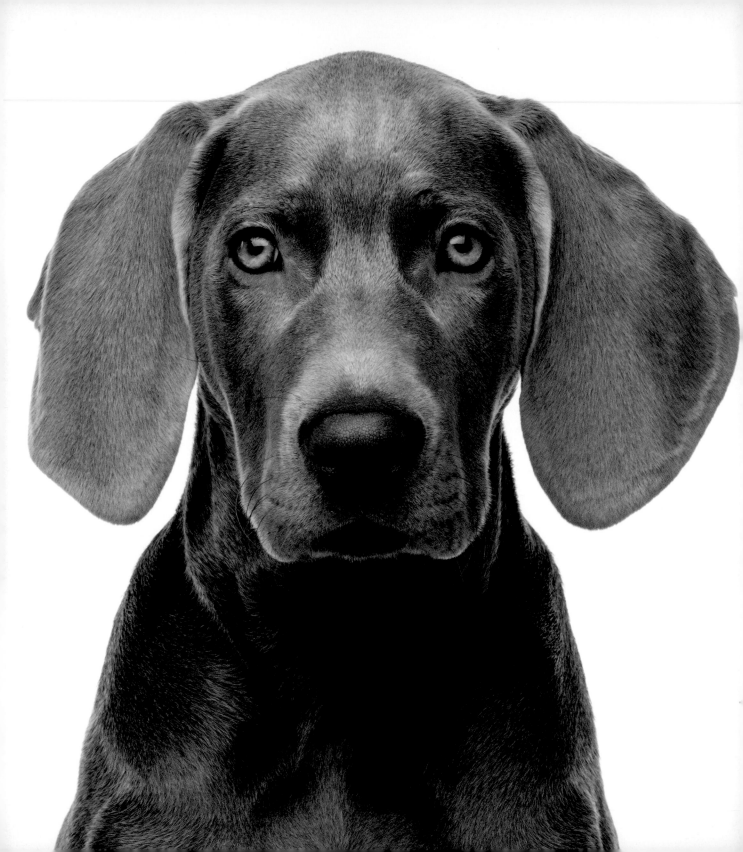

We long for an affection altogether ignorant of our faults. Heaven has accorded this to us in the uncritical canine attachment.

GEORGE ELIOT

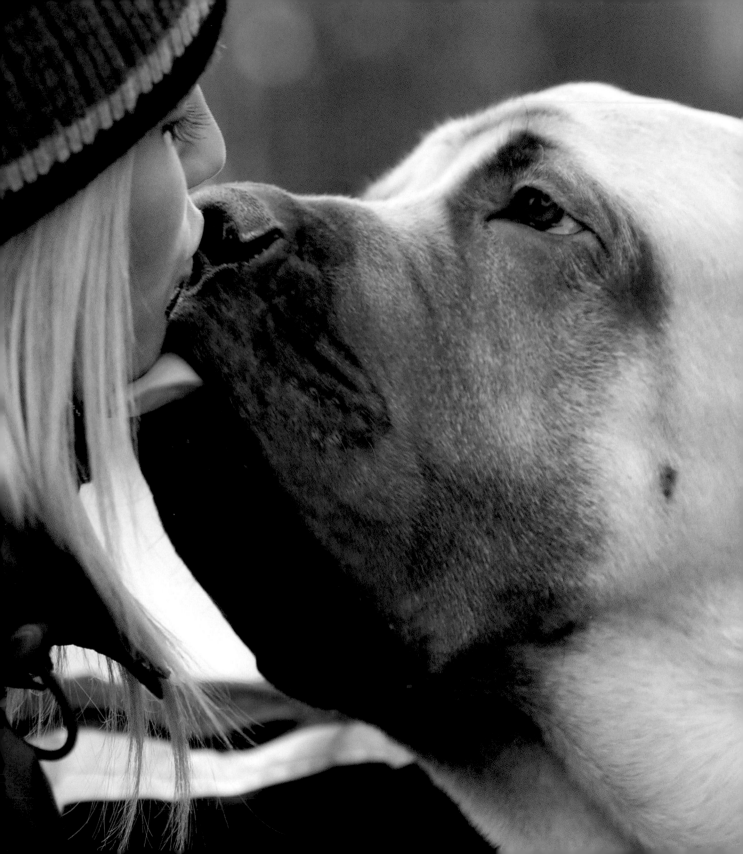

One reason a dog can be
such a comfort when you're
feeling blue is that he doesn't
try to find out why.

UNKNOWN

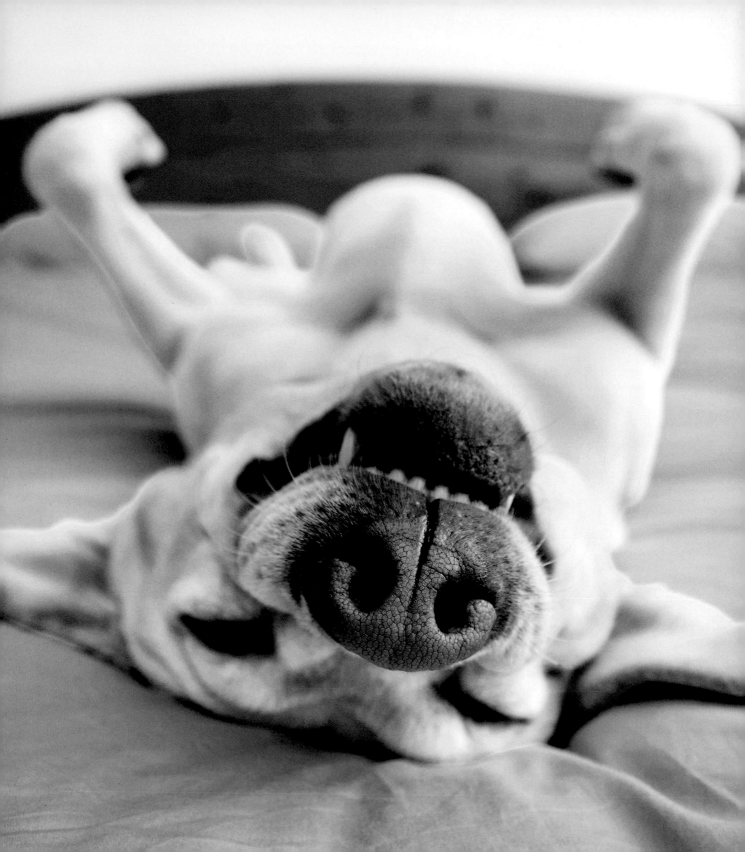

Scratch a dog and you'll
find a permanent job.

FRANKLIN P. JONES

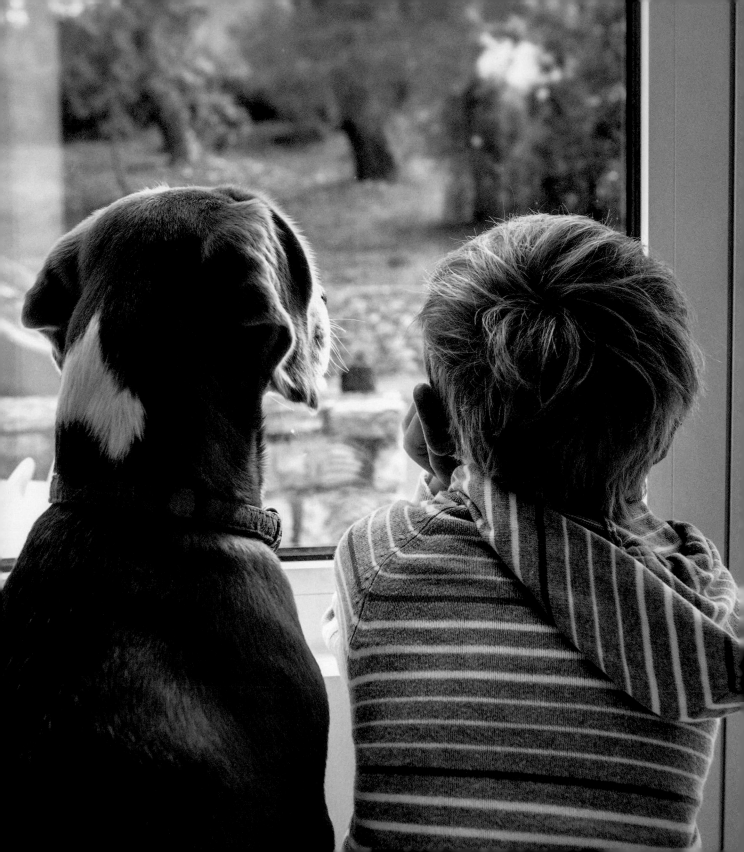

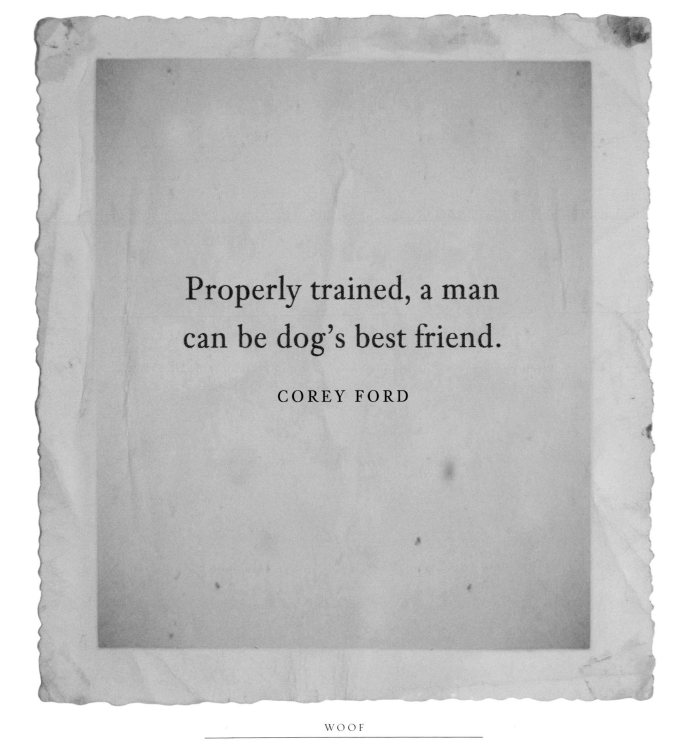

Properly trained, a man
can be dog's best friend.

COREY FORD

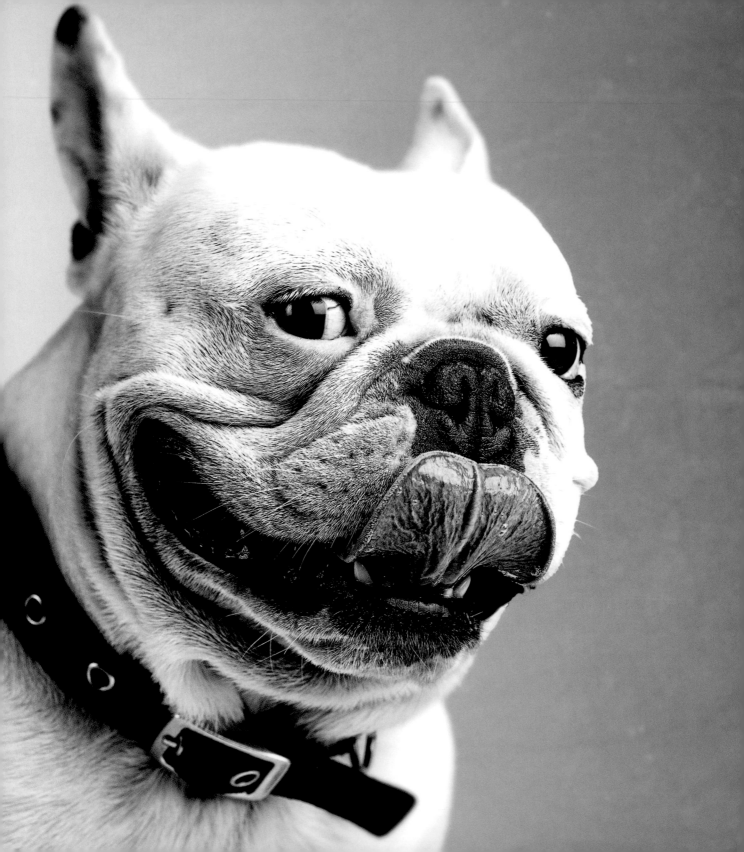

If you think dogs can't count,
try putting three dog biscuits
in your pocket and then giving
Fido only two of them.

PHIL PASTORET

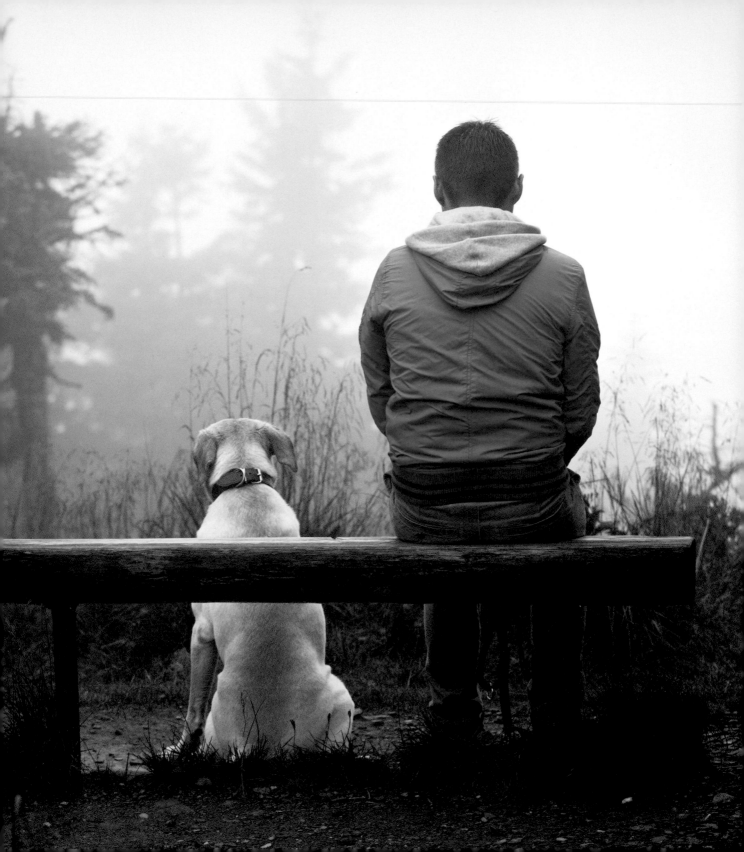

With the exception of women,
there is nothing on earth so
agreeable or necessary to the
comfort of man as the dog.

EDWARD JESSE

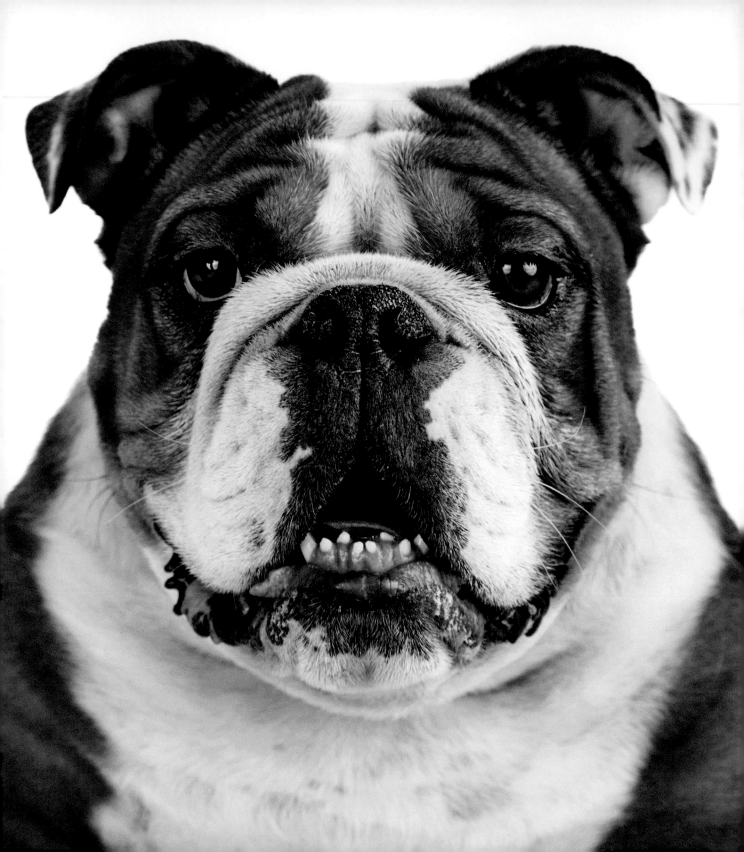

Bulldogs are adorable, with faces
like toads that have been sat on.

COLETTE

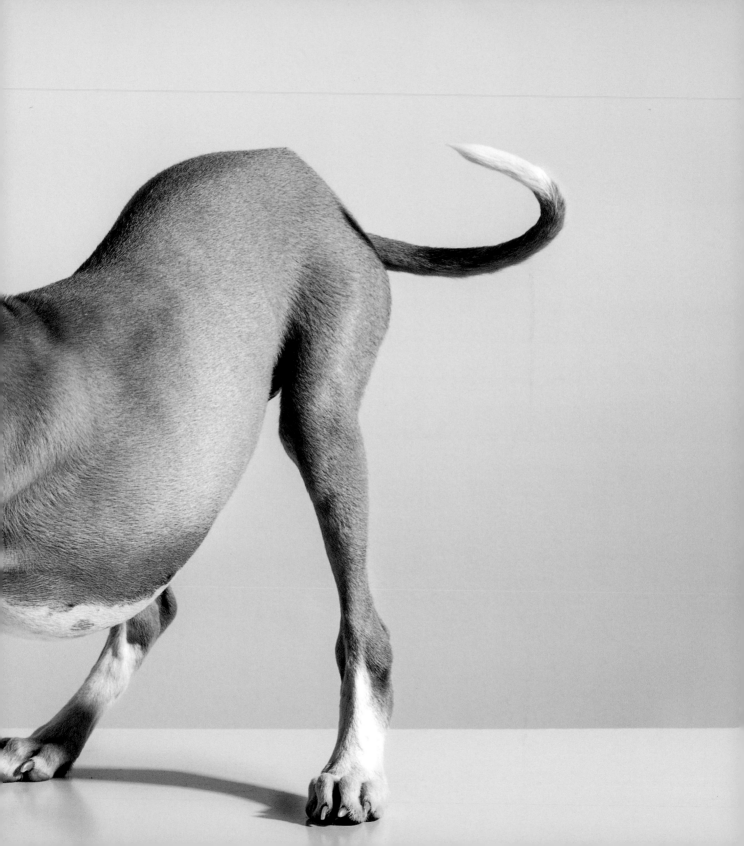

Dogs laugh, but they laugh
with their tails.

MAX EASTMAN

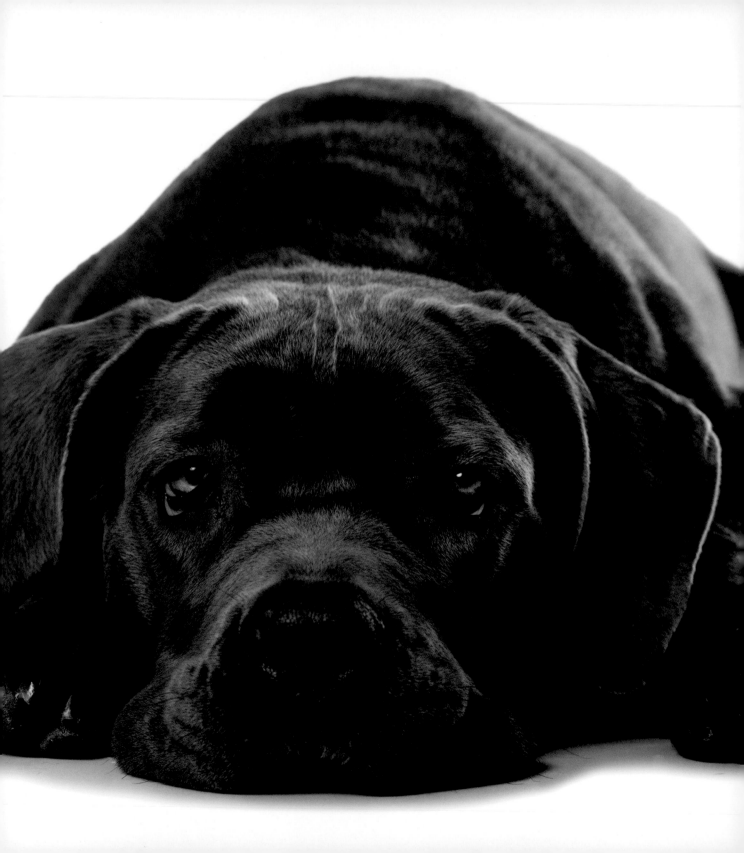

My goal in life is to be as good a person as my dog already thinks I am.

UNKNOWN

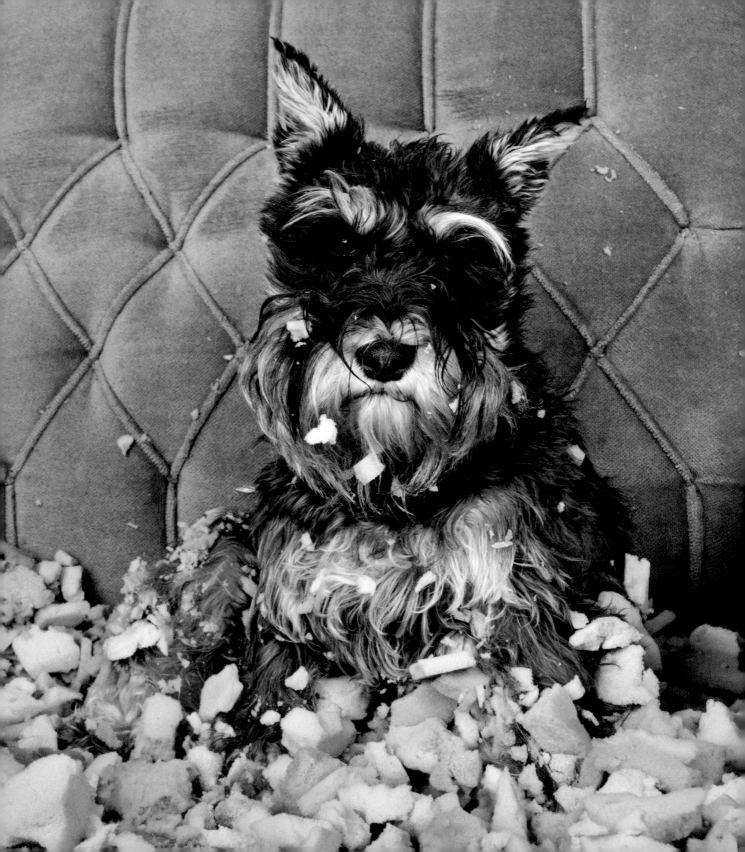

If you get to thinking you're a person
of some influence, try ordering
somebody else's dog around.

WILL ROGERS

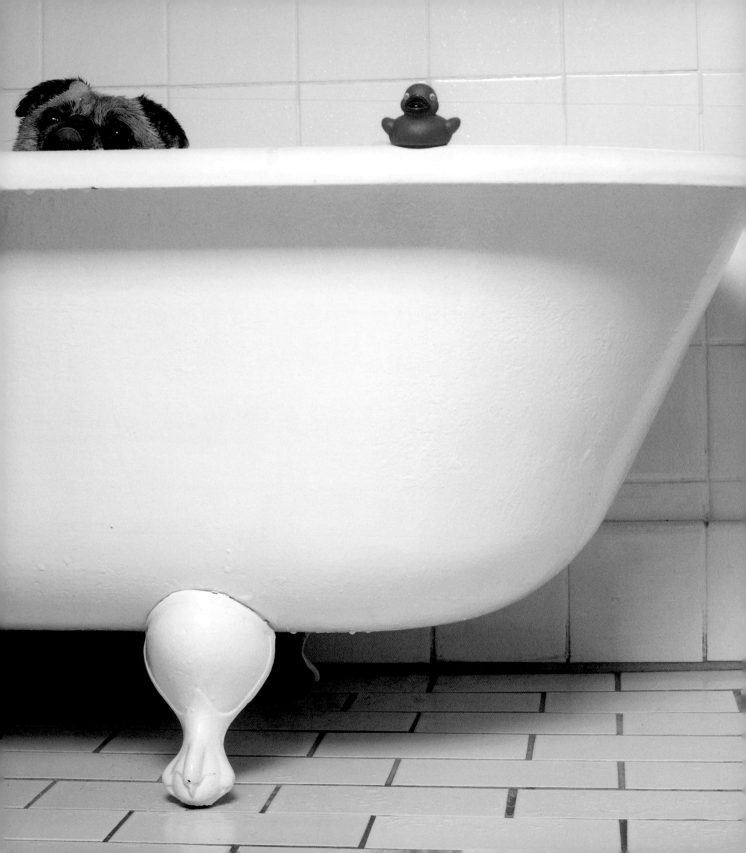

The more I see of man,
the more I like dogs.

MADAME DE STAËL

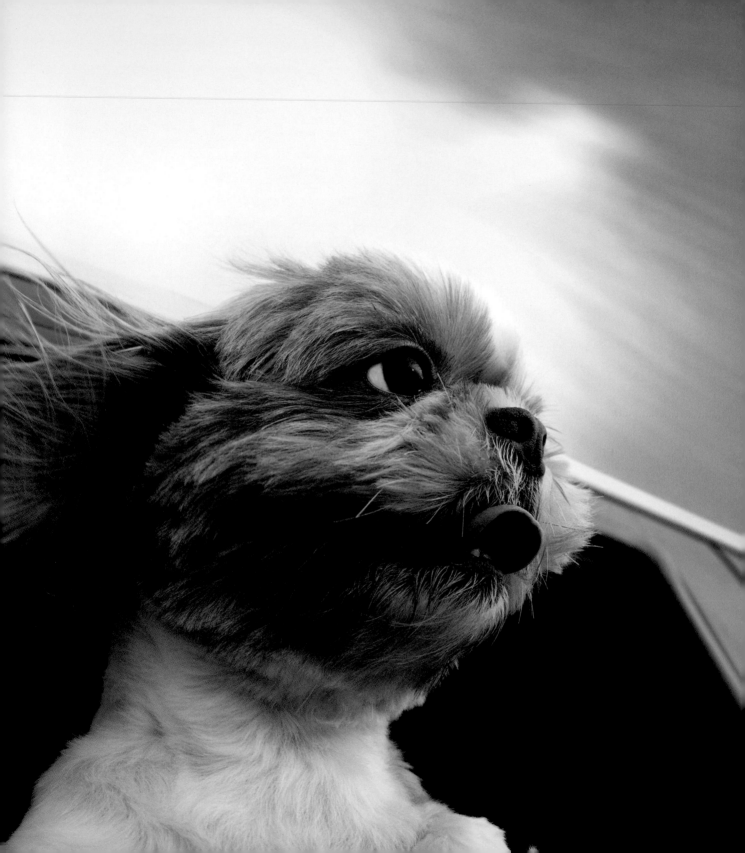

Did you ever notice when you blow in a dog's face he gets mad at you? But when you take him in a car he sticks his head out the window.

STEVE BLUESTONE

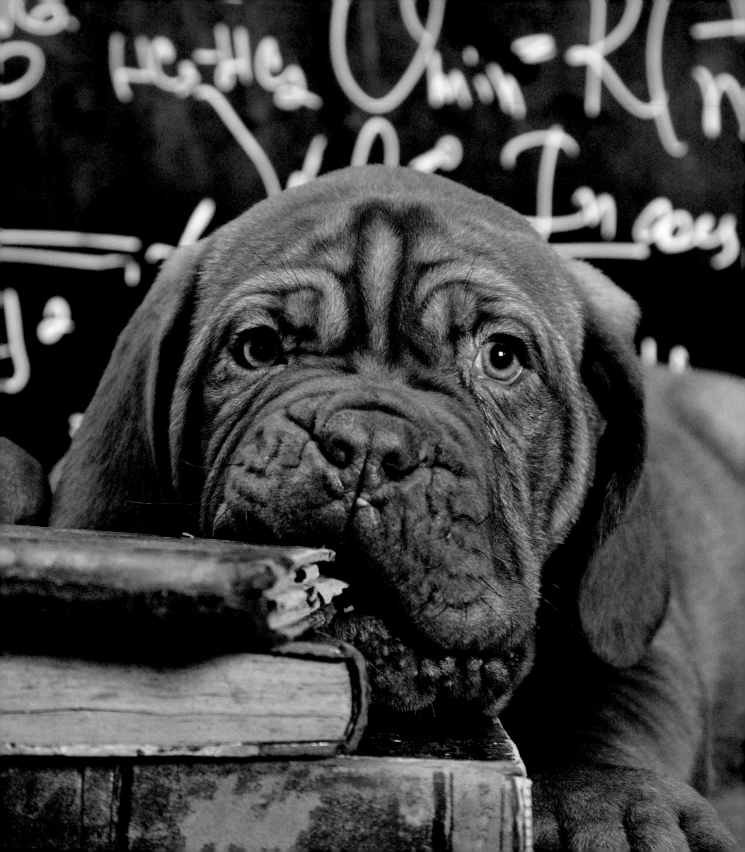

To his dog, every man is Napoleon; hence the constant popularity of dogs.

ALDOUS HUXLEY

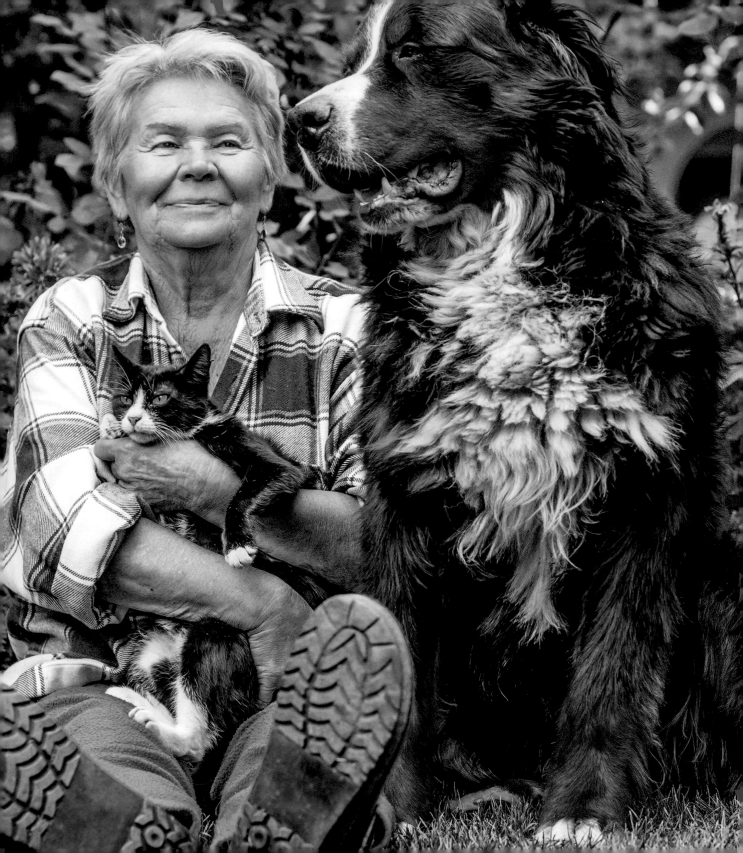

Dogs are not our whole life, but they make our lives whole.

ROGER CARAS

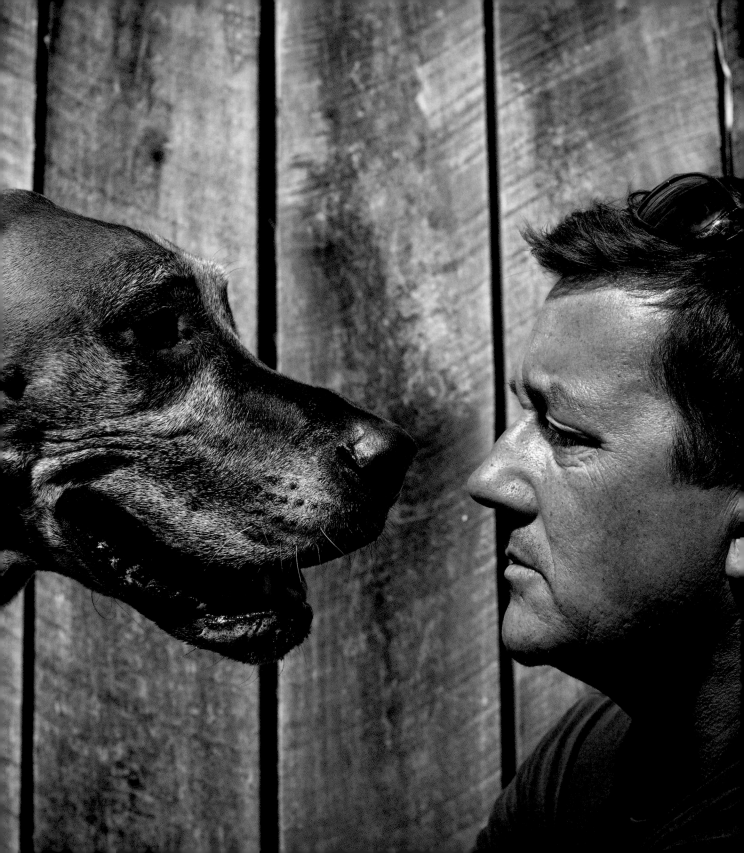

They never talk about
themselves but listen to you
while you talk about yourself,
and keep up an appearance
of being interested in the
conversation.

JEROME K. JEROME

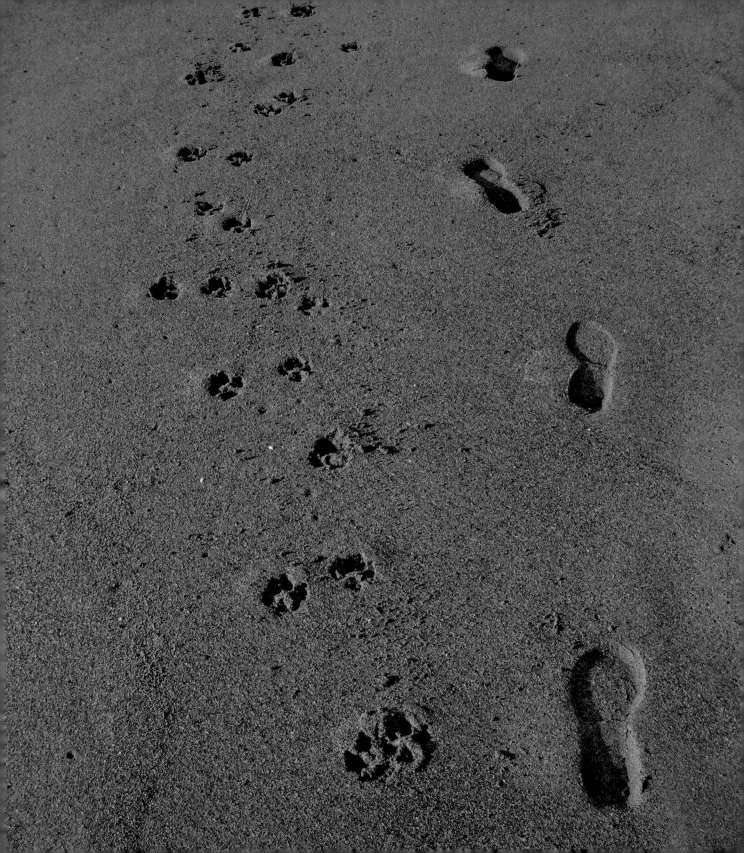

A dog is one of the remaining reasons why some people can be persuaded to go for a walk.

O.A. BATTISTA

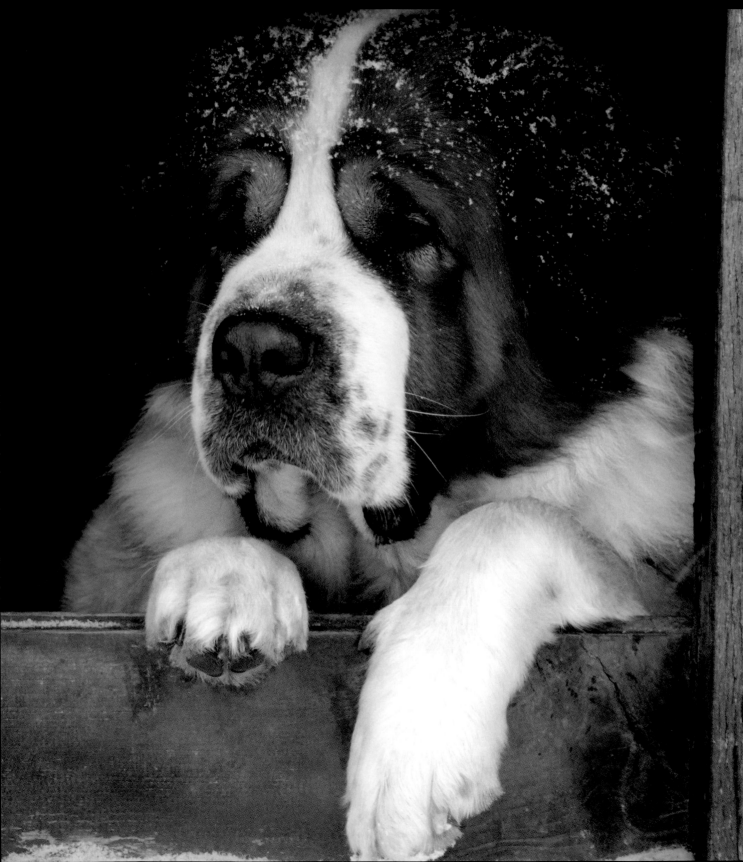

The dog is a gentleman; I hope to
go to his heaven, not man's.

MARK TWAIN

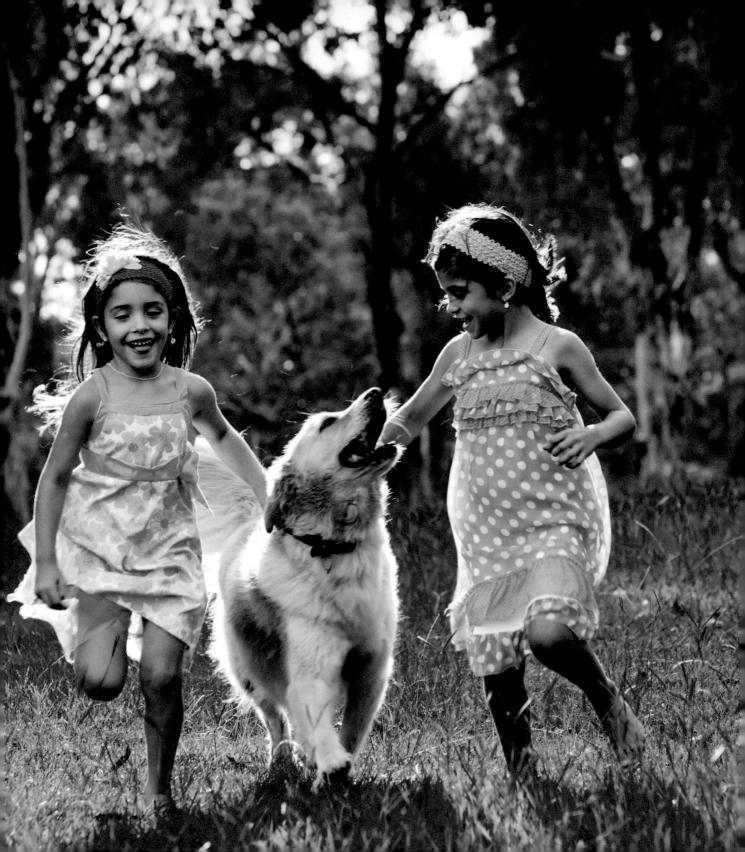

The dog was created
specially for children.
He is the god of frolic.

HENRY WARD BEECHER

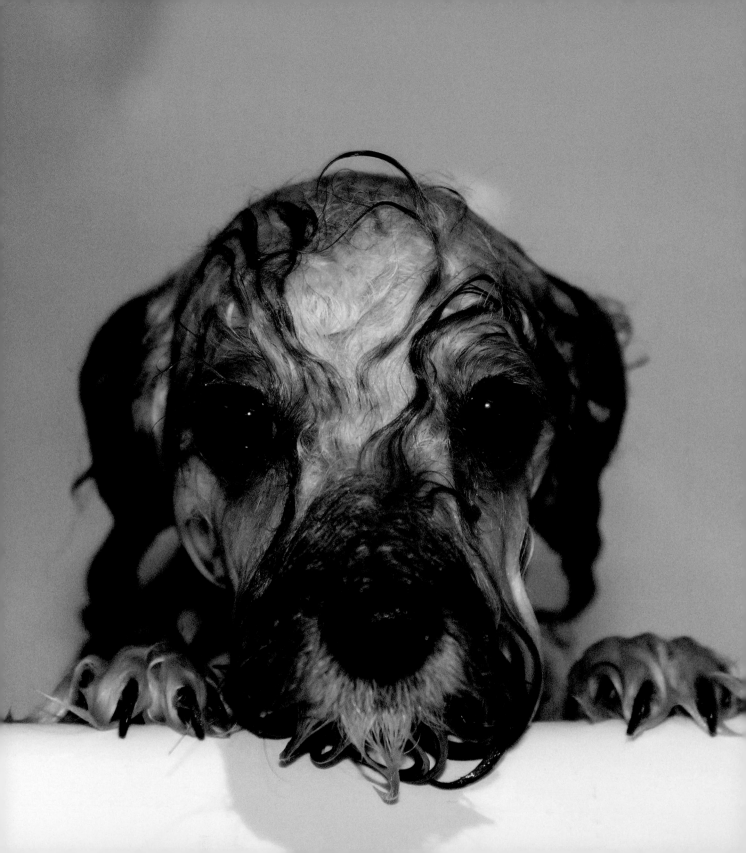

The most affectionate creature
in the world is a wet dog.

AMBROSE BIERCE

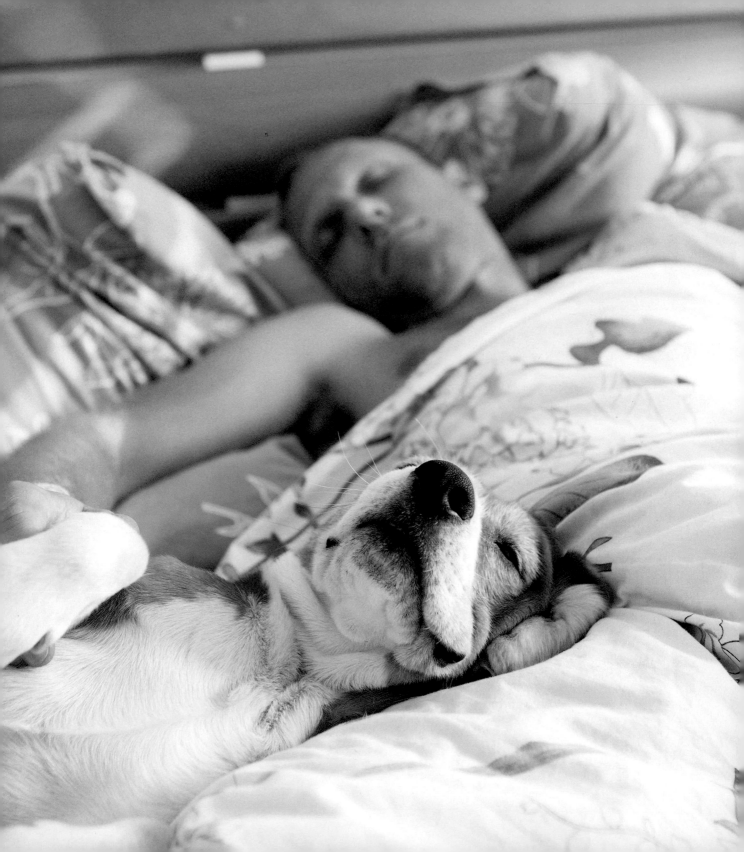

An old dog, even more than
an old spouse, always feels like
doing what you feel like doing.

ROBERT BRAULT

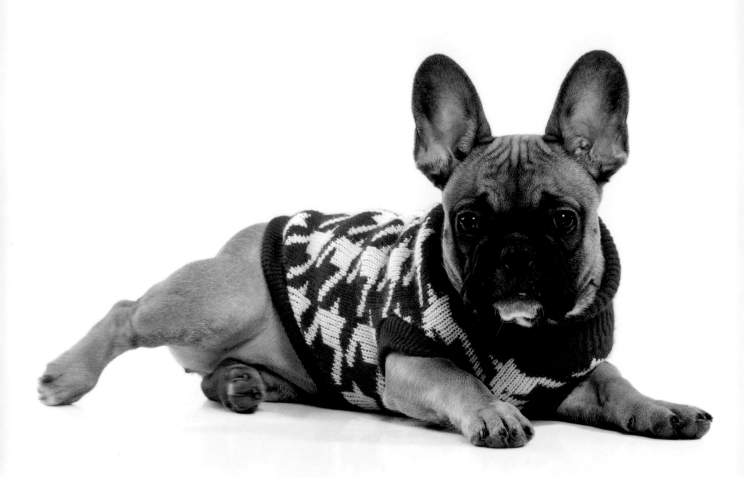

If you are a dog and your owner
suggests that you wear a sweater ...
suggest that he wear a tail.

FRAN LEBOWITZ

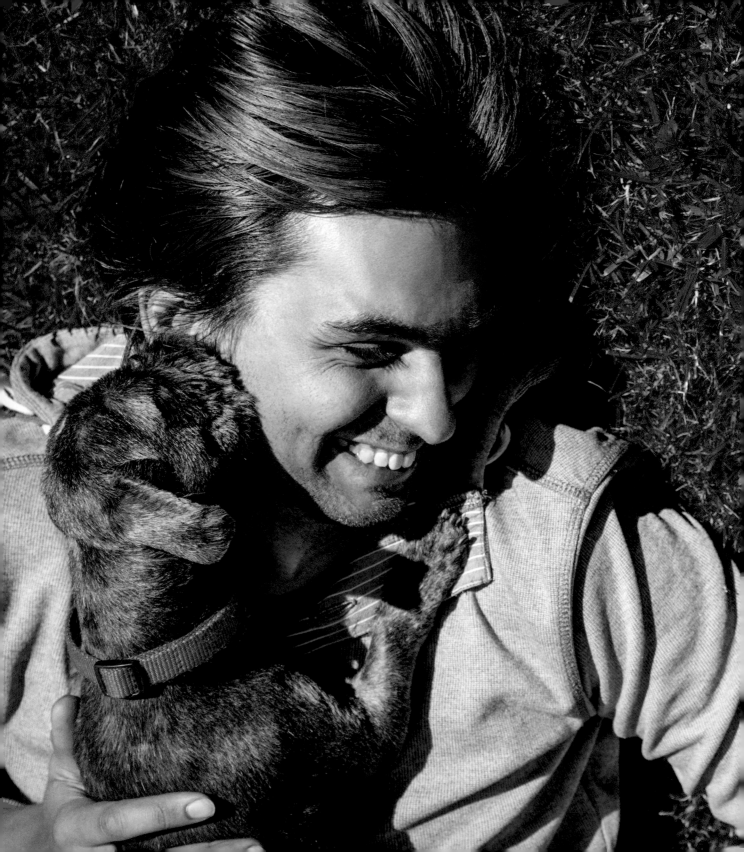

The greatest love is a
mother's; then a dog's;
then a sweetheart's.

POLISH PROVERB

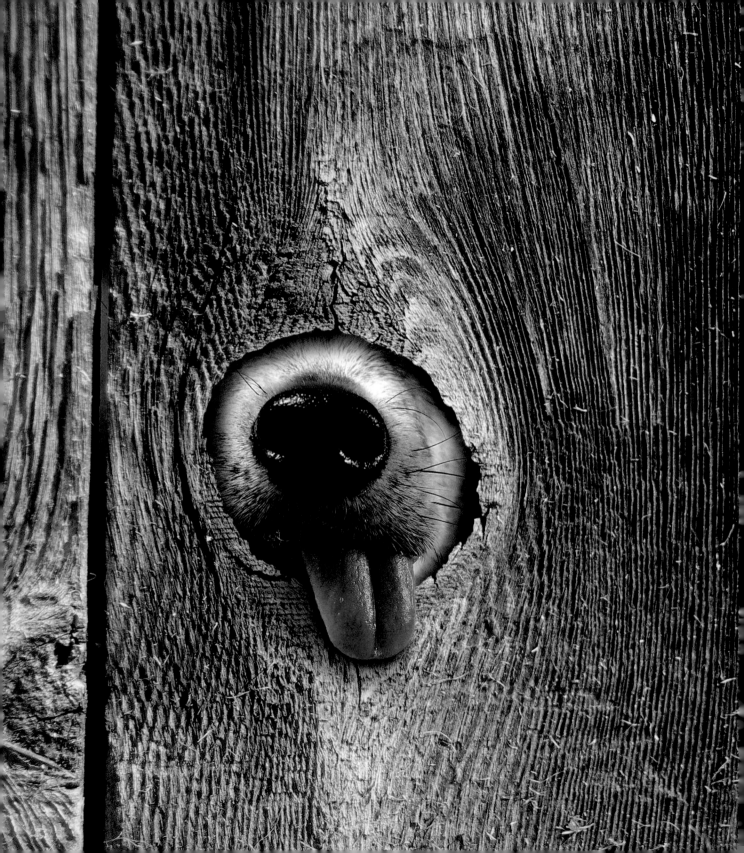

A door is what a dog
is perpetually on the
wrong side of.

OGDEN NASH

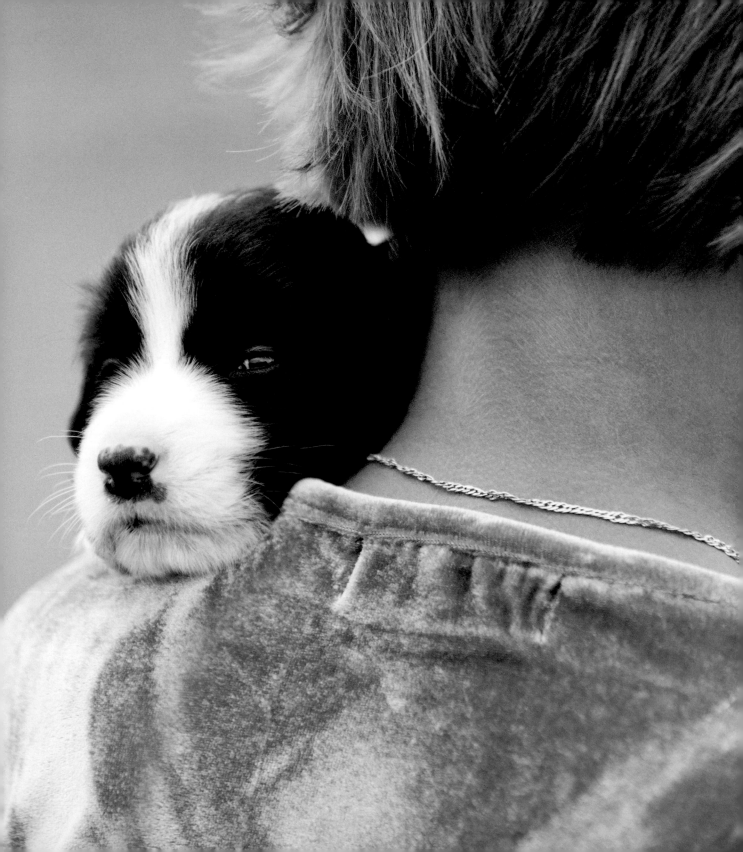

Happiness is a warm puppy.

CHARLES M. SCHULZ

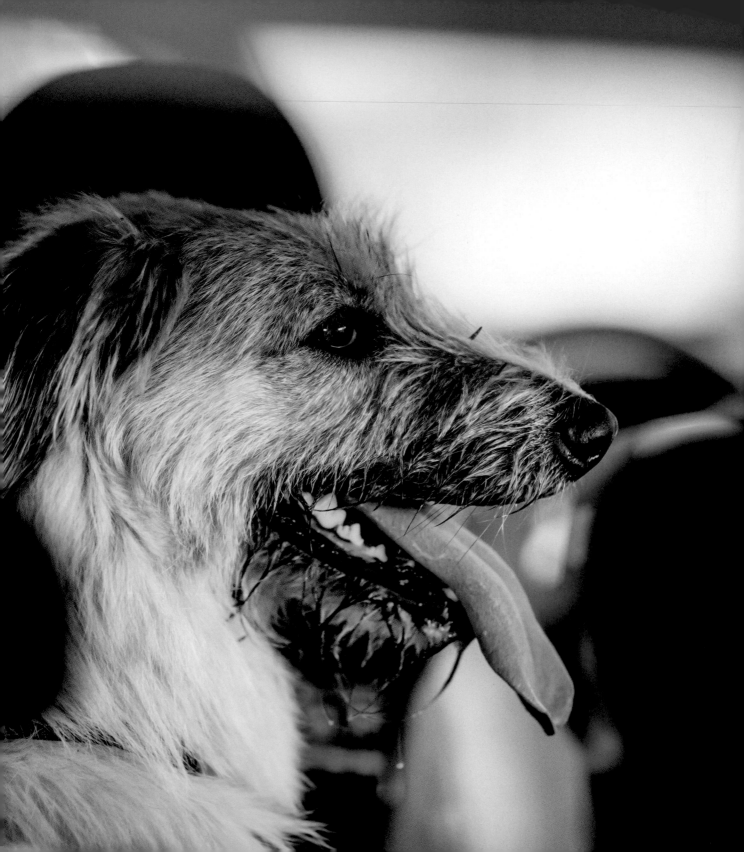

Dogs feel very strongly that they should always go with you in the car, in case the need should arise for them to bark violently at nothing right in your ear.

DAVE BARRY

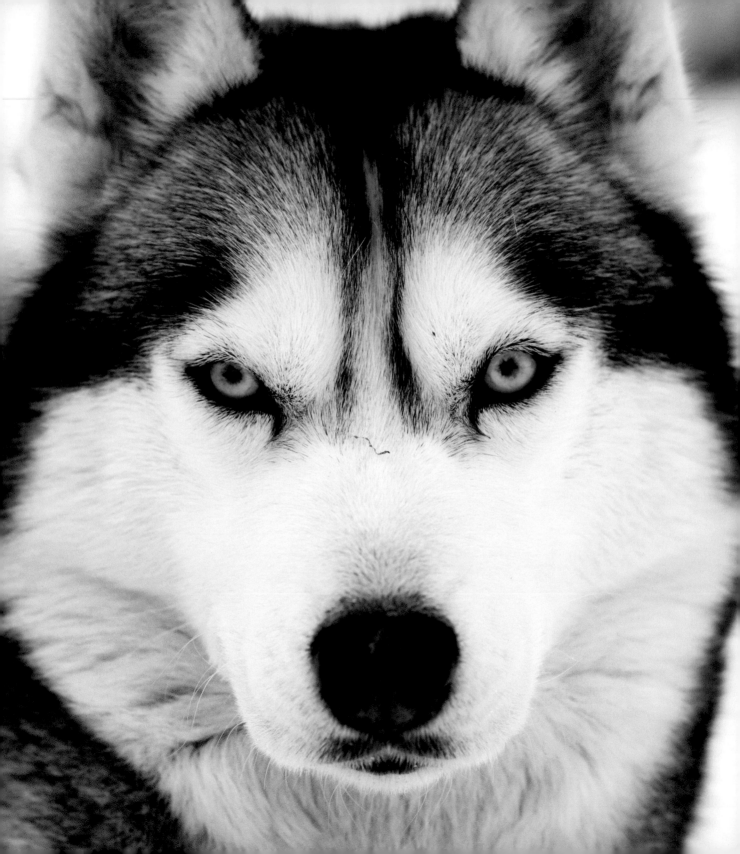

I always like a dog so long as
he isn't spelled backward.

G.K. CHESTERTON

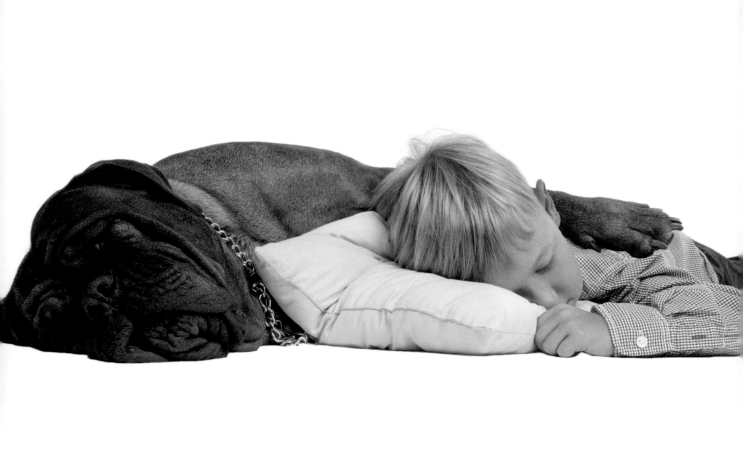

A dog teaches a boy fidelity, perseverance, and to turn around three times before lying down.

ROBERT BENCHLEY

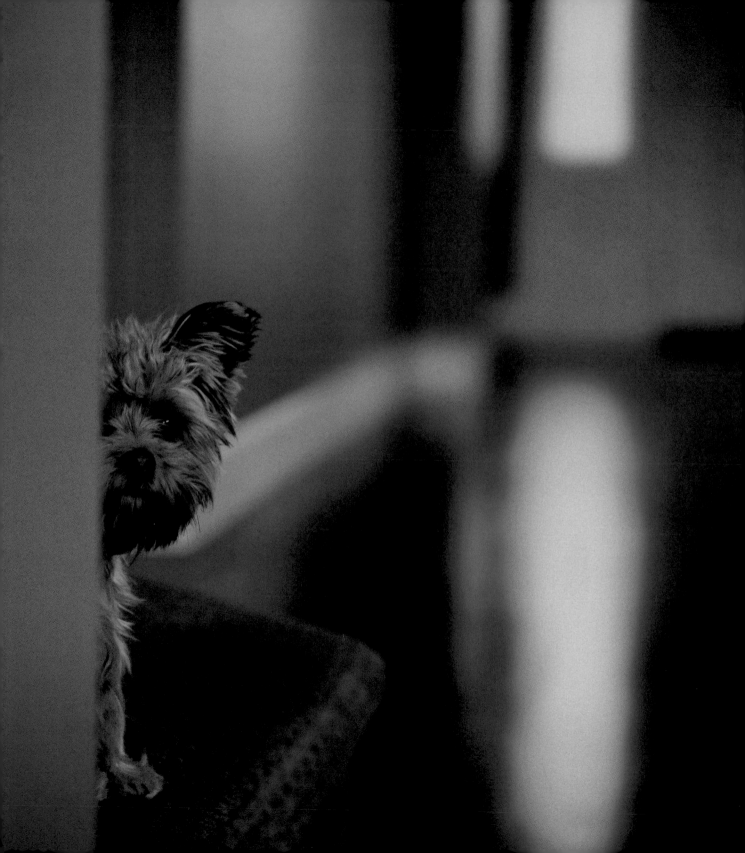

If a dog will not come to you after having looked you in the face, you should go home and examine your conscience.

WOODROW WILSON

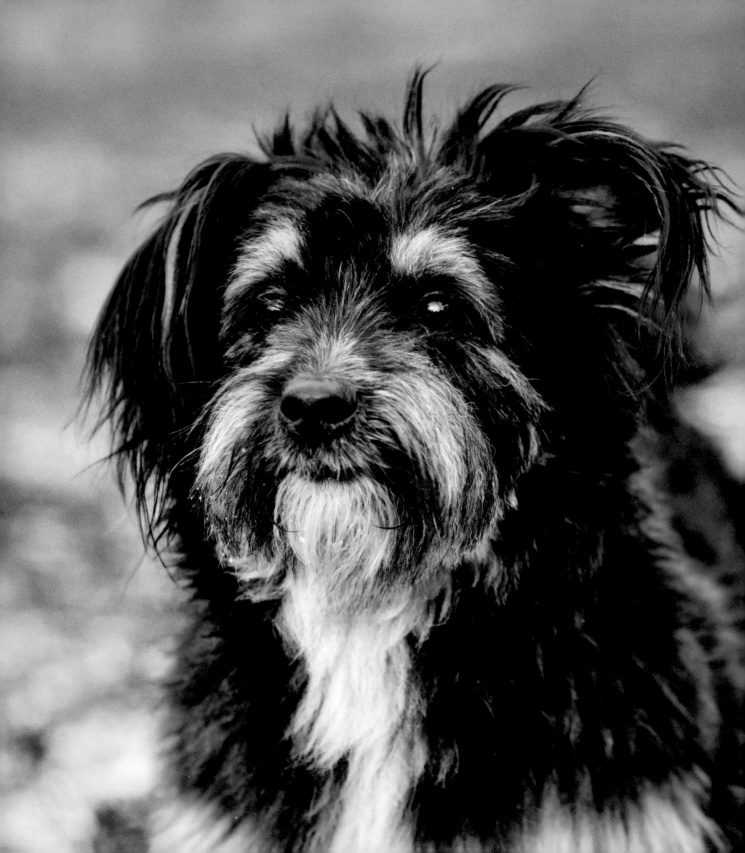

I like a bit of a mongrel
myself, whether it's a man
or a dog; they're the best
for everyday.

GEORGE BERNARD SHAW

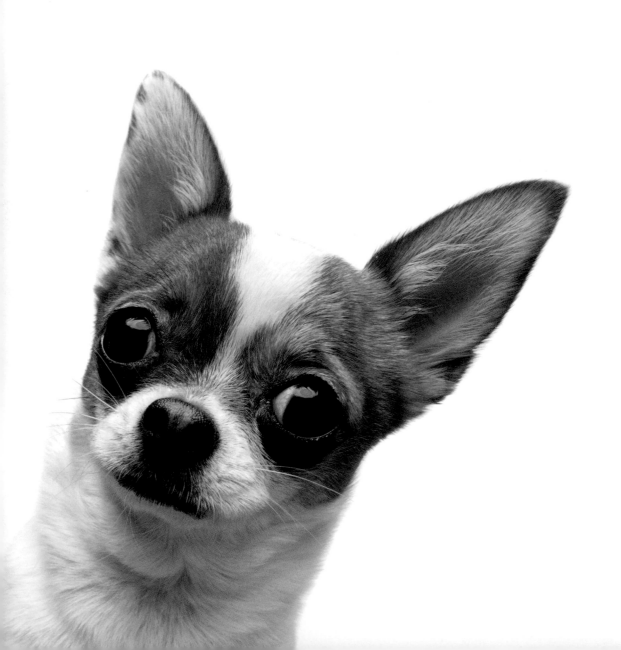

I wonder what goes through his
mind when he sees us peeing
in his water bowl.

PENNY WARD MOSER

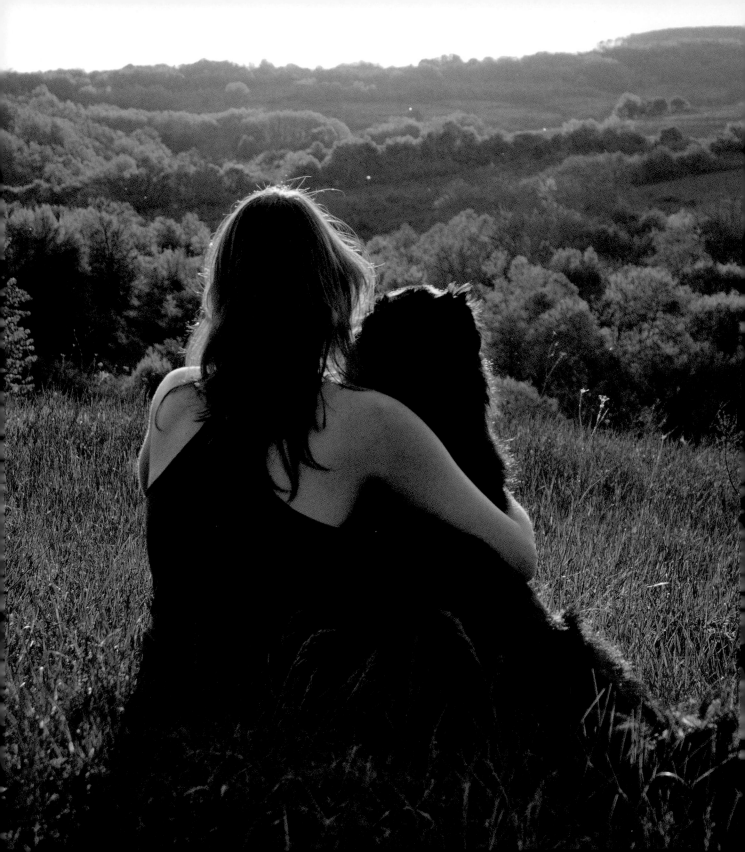

Dogs are our link to paradise. They don't know evil or jealousy or discontent. To sit with a dog on a hillside on a glorious afternoon is to be back in Eden, where doing nothing was not boring — it was peace.

MILAN KUNDERA

A dog can express more with his tail in seconds than his owner can express with his tongue in hours.

UNKNOWN

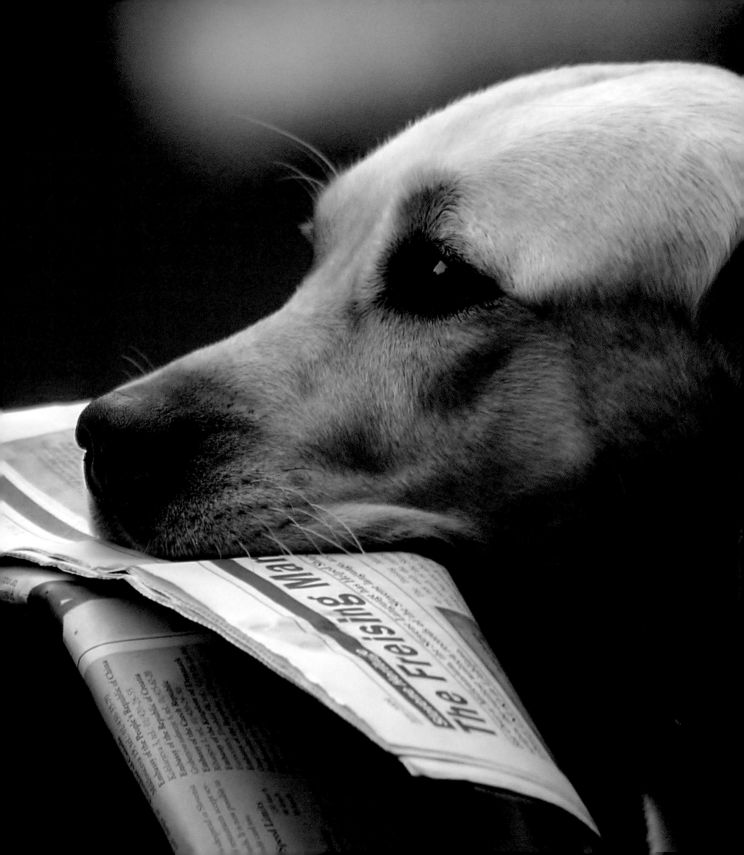

Labradors are lousy watchdogs. They usually bark when there is a stranger about, but it is an expression of unmitigated joy at the chance to meet somebody new, not a warning.

NORMAN STRUNG

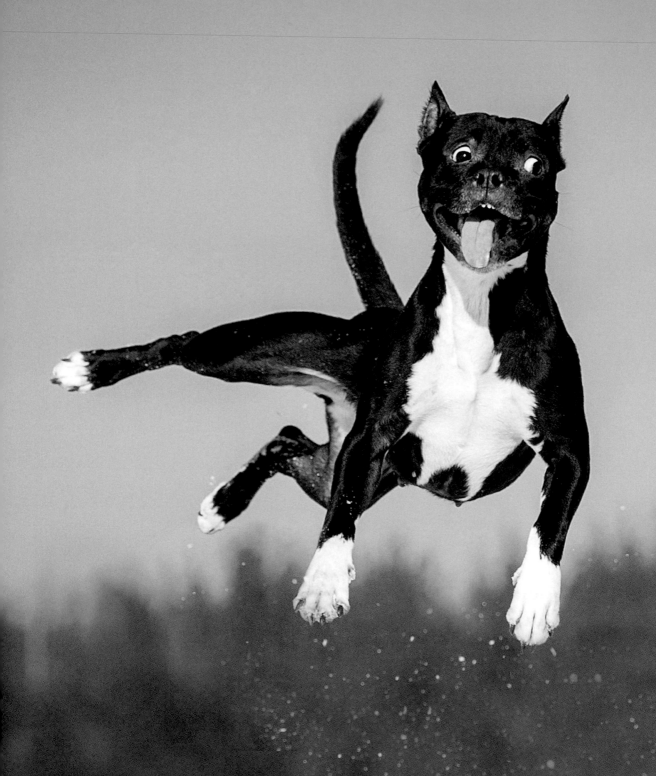

If you can look at a dog and
not feel vicarious excitement and
affection, you must be a cat.

CARRIE LATET

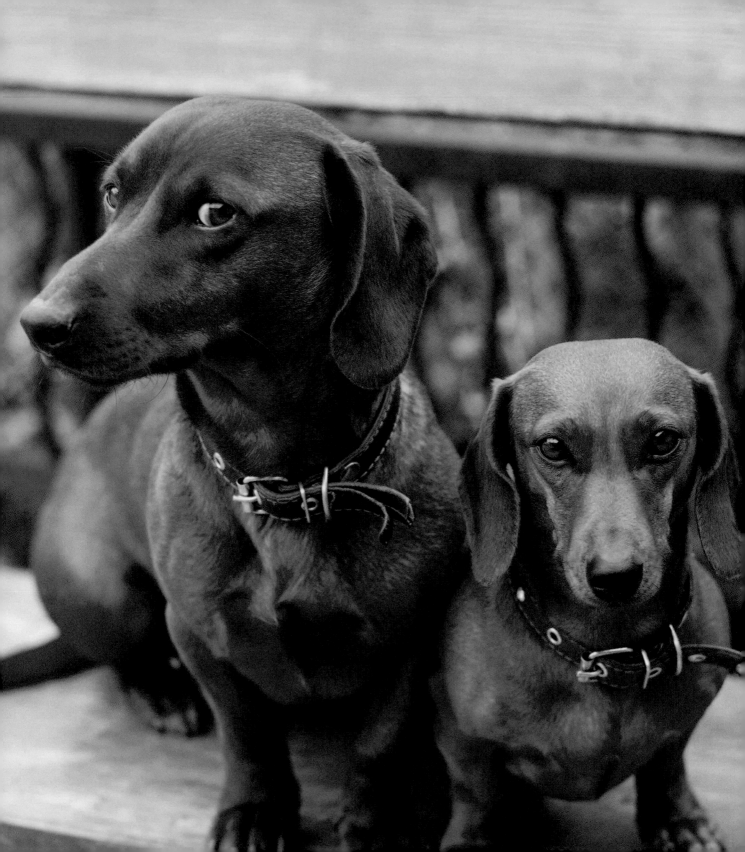

Dachshunds are ideal dogs
for small children, as they are
already stretched and pulled
to such a length that the child
cannot do much harm one
way or the other.

ROBERT BENCHLEY

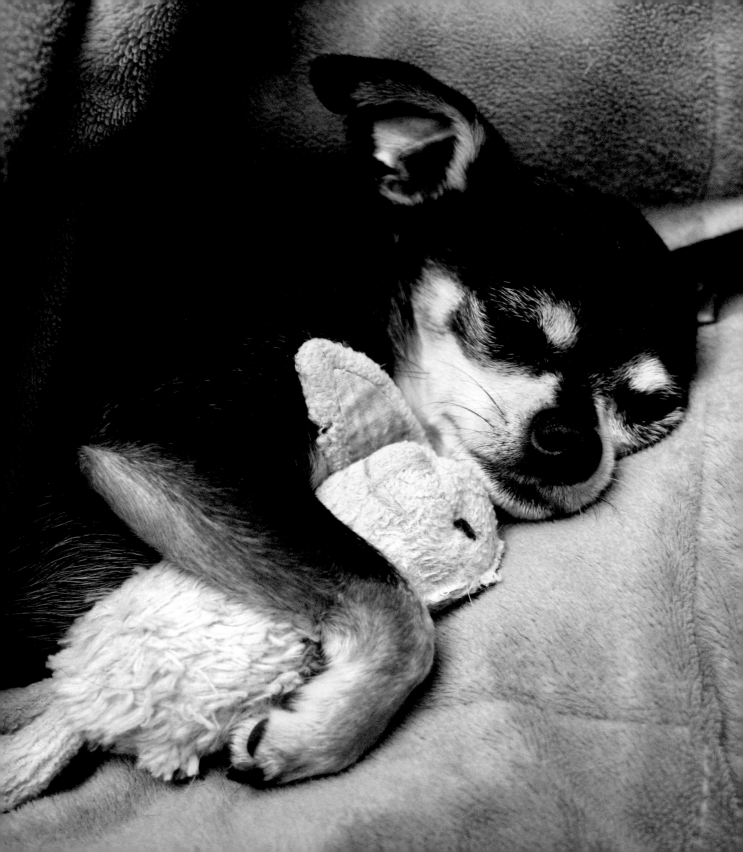

Let sleeping dogs lie.

CHARLES DICKENS

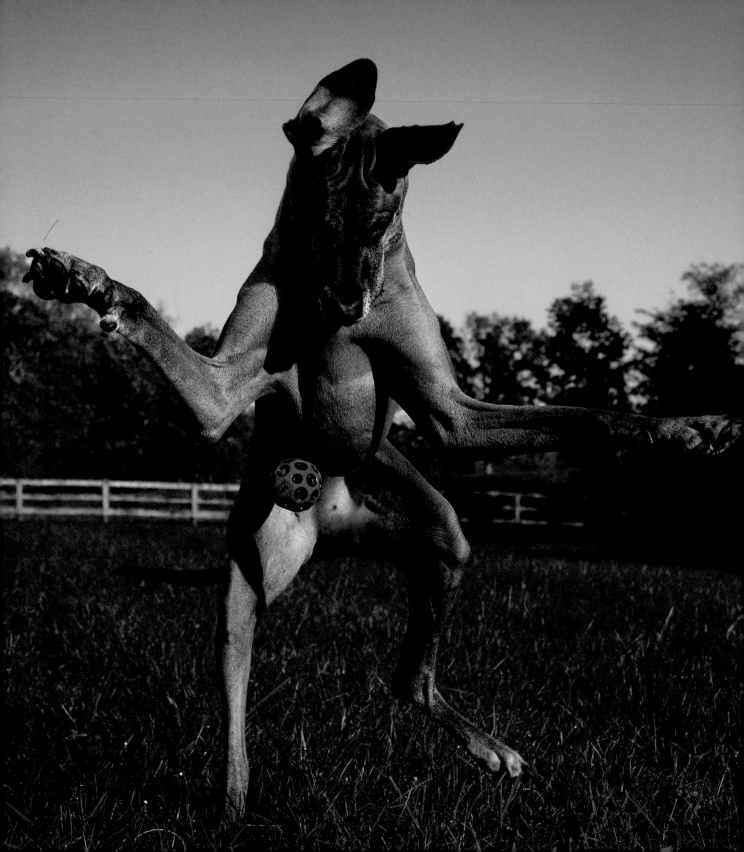

I think we are drawn to dogs because they are the uninhibited creatures we might be if we weren't certain we knew better.

GEORGE BIRD EVANS

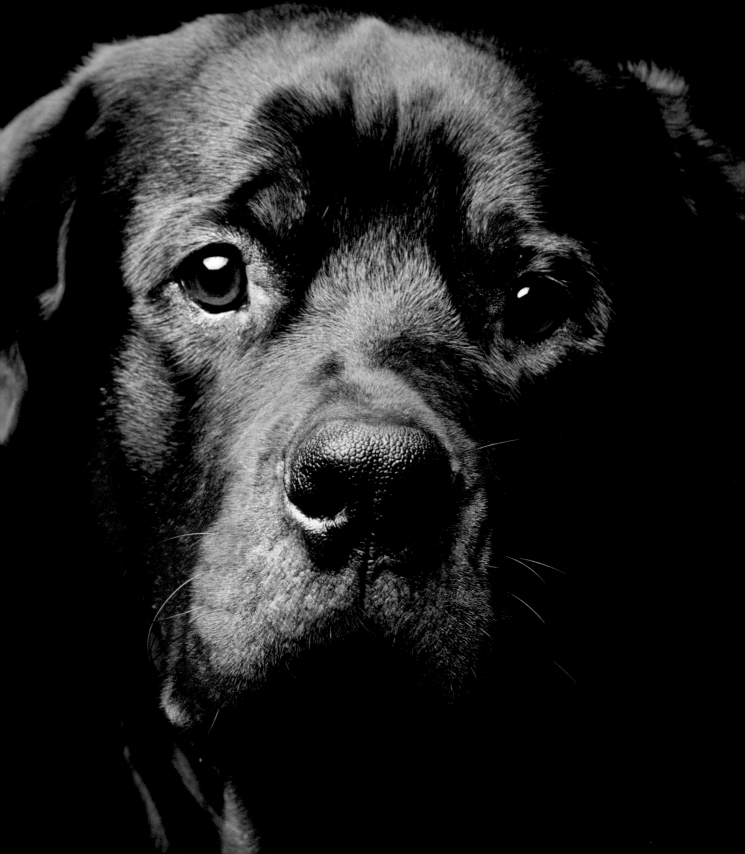

The world was conquered
through the understanding
of dogs; the world exists through
the understanding of dogs.

NIETZSCHE

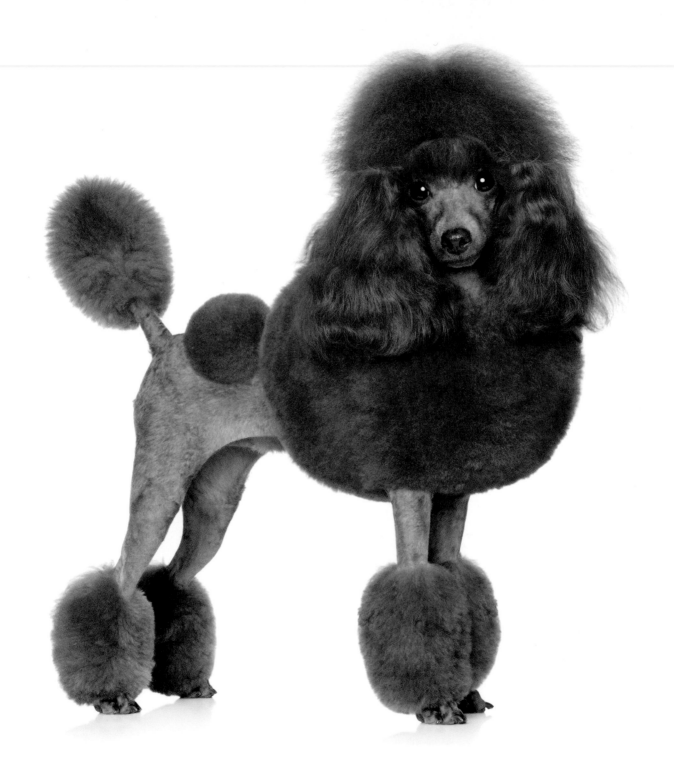

I wonder if other dogs think poodles are members of a weird religious cult.

RITA RUDNER

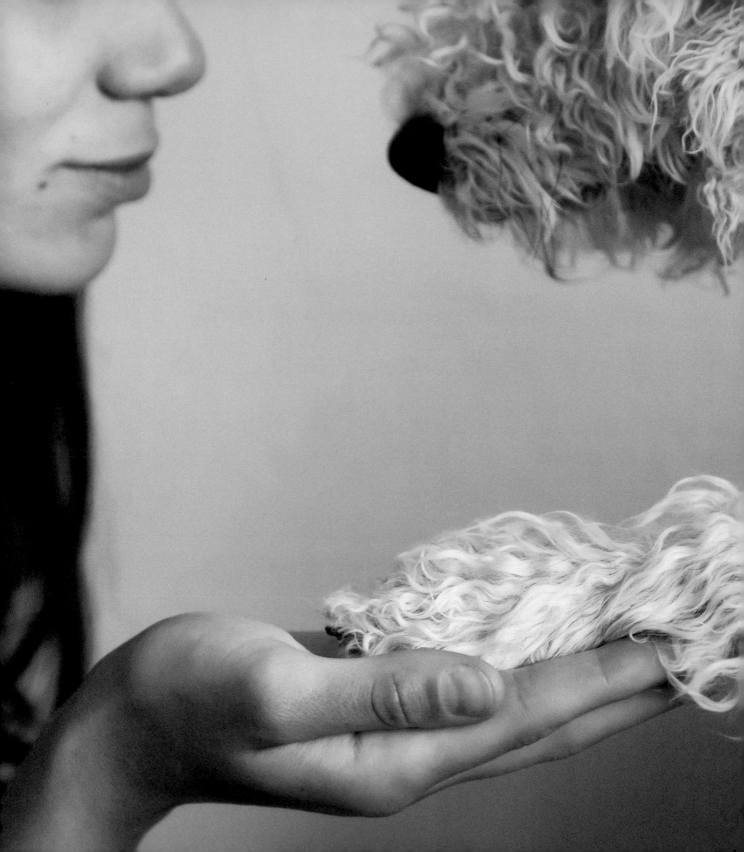

A dog is the only thing
on earth that loves you more
than he loves himself.

JOSH BILLINGS

No matter how little money
and how few possessions you
own, having a dog makes you rich.

LOUIS SABIN

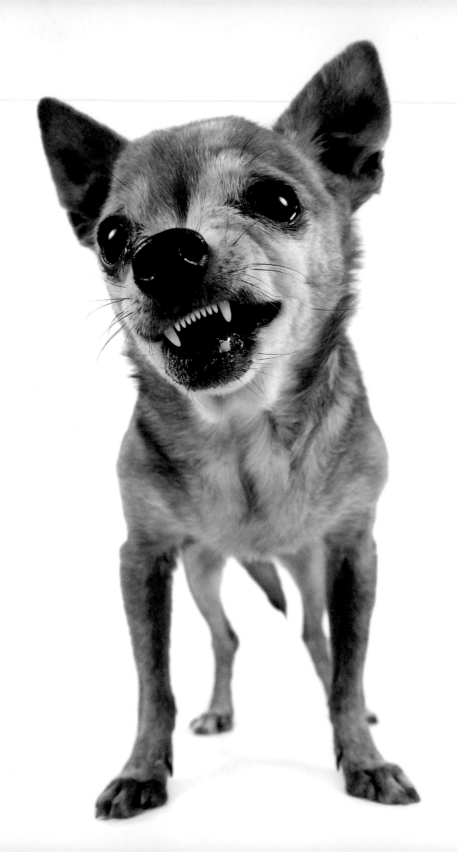

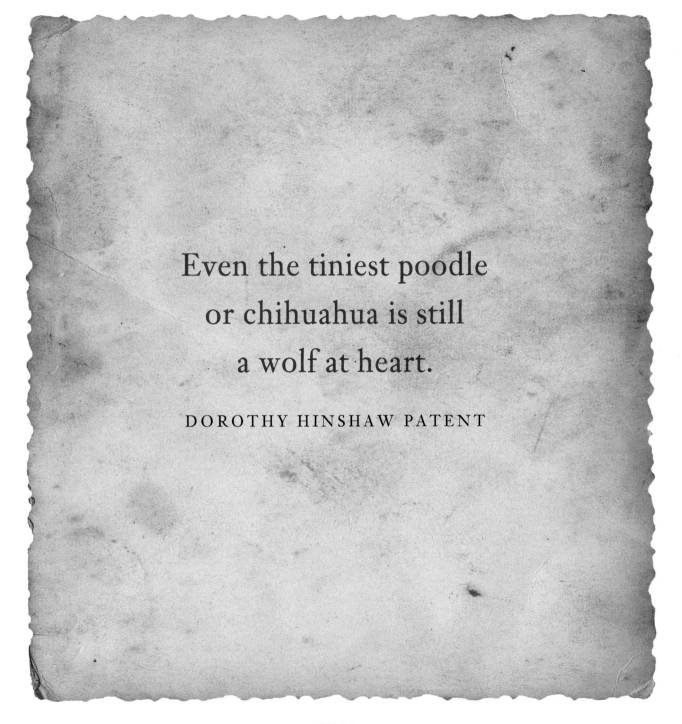

Even the tiniest poodle
or chihuahua is still
a wolf at heart.

DOROTHY HINSHAW PATENT

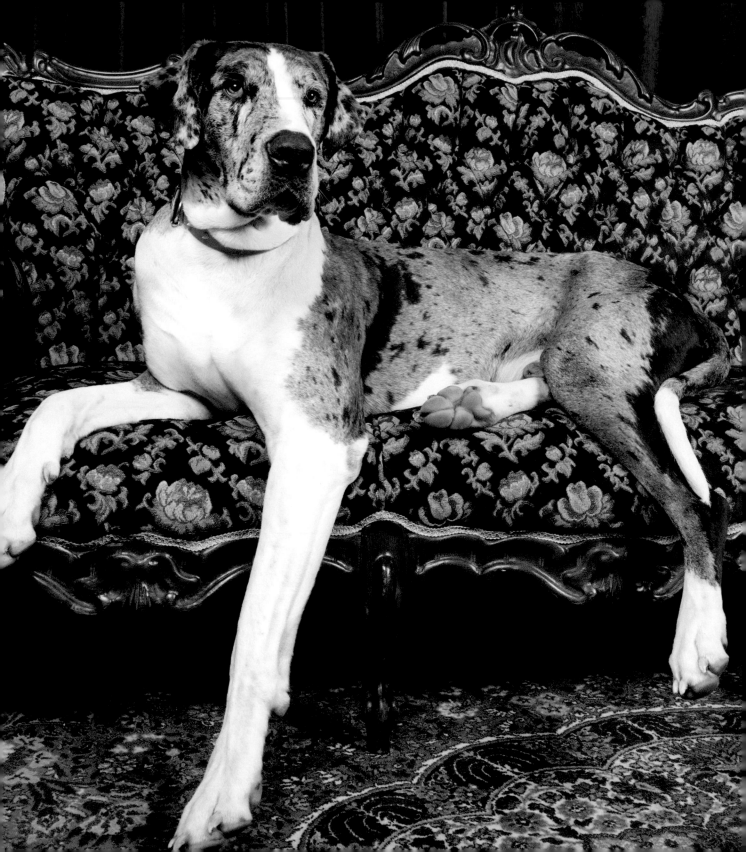

Things that upset a terrier
may pass virtually unnoticed
by a Great Dane.

SMILEY BLANTON

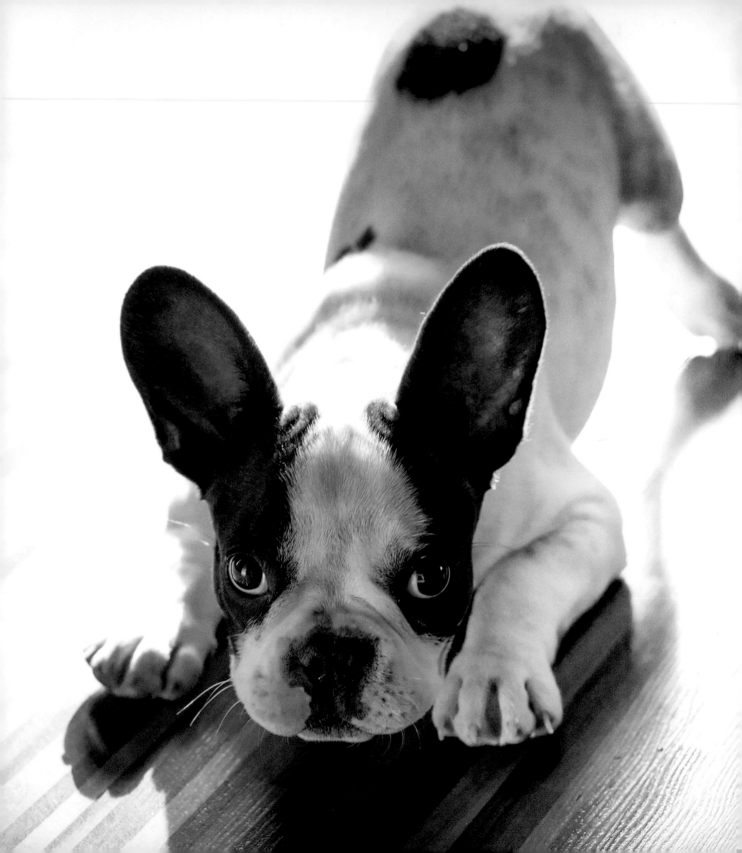

What counts is not
necessarily the size of the dog
in the fight; it's the size of
the fight in the dog.

DWIGHT D. EISENHOWER

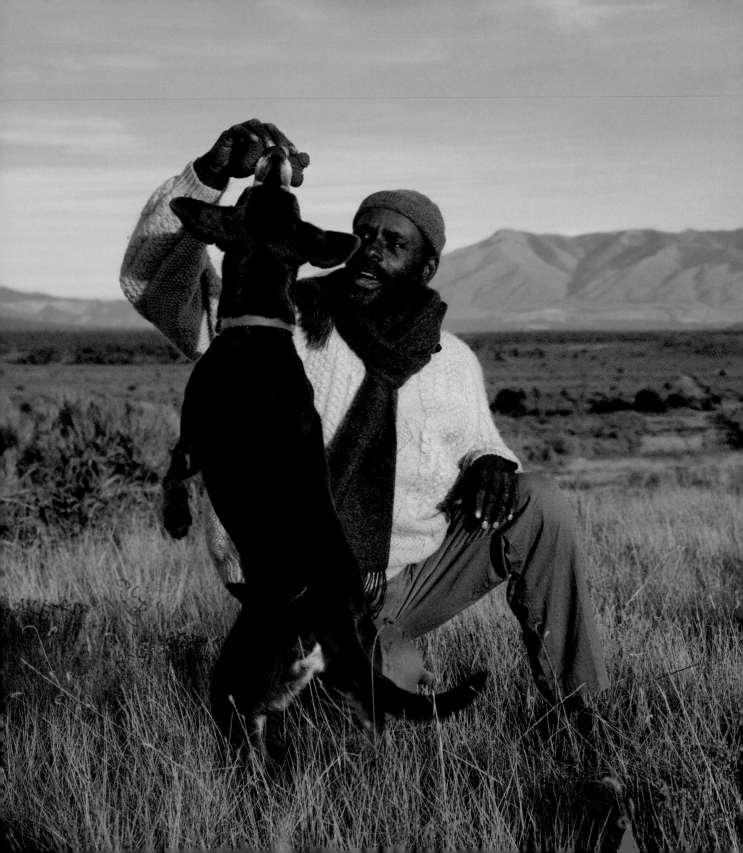

The one absolutely unselfish friend that man can have in this selfish world, the one that never deserts him, the one that never proves ungrateful or treacherous, is his dog ... He will kiss the hand that has no food to offer; he will lick the wounds and sores that come in encounter with the roughness of the world ... When all other friends desert, he remains.

GEORGE G. VEST

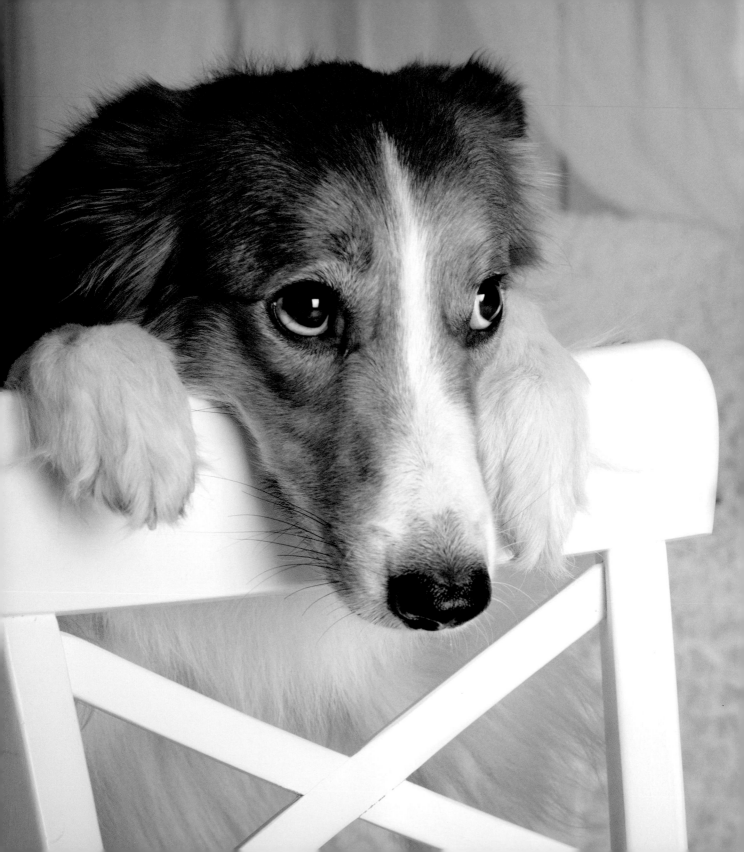

Know yourself. Don't accept your dog's admiration as conclusive evidence that you are wonderful.

ANN LANDERS

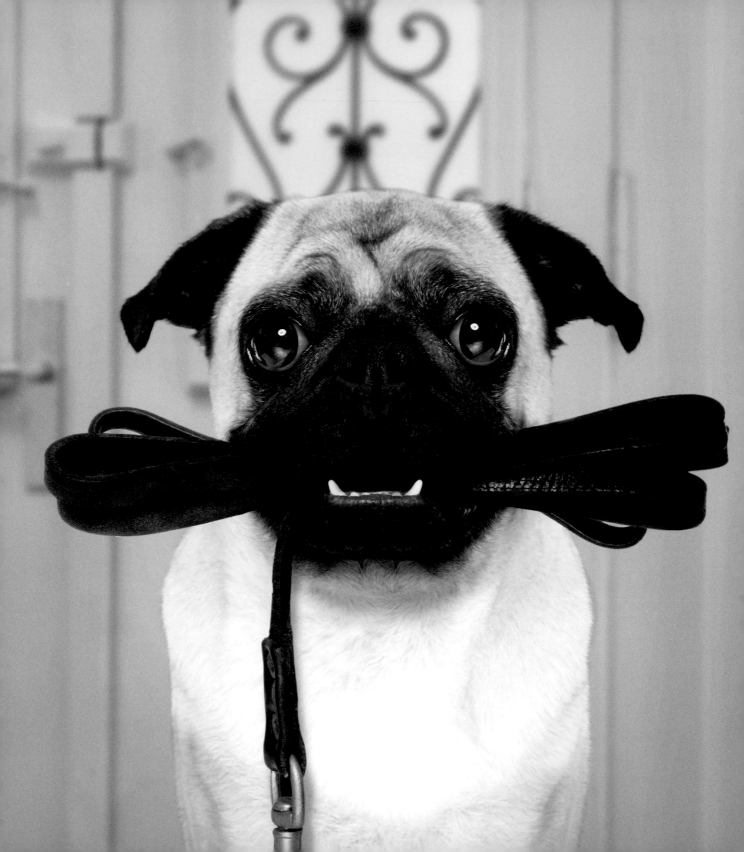

He is your friend, your partner, your defender, your dog. You are his life, his love, his leader. He will be yours, faithful and true, to the last beat of his heart. You owe it to him to be worthy of such devotion.

UNKNOWN

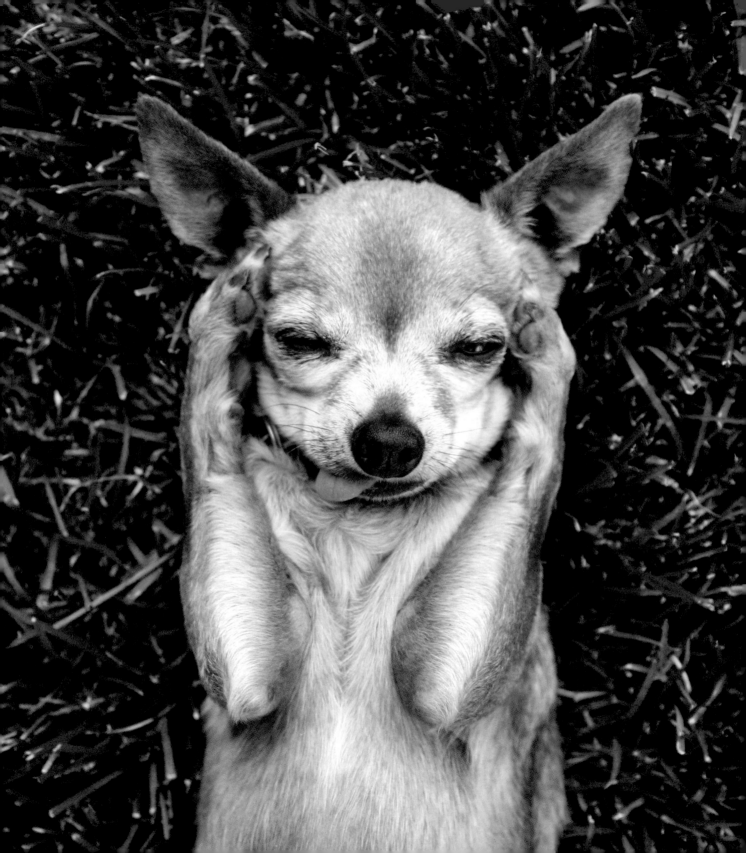

All knowledge, the totality
of all questions and all answers
is contained in the dog.

KAFKA

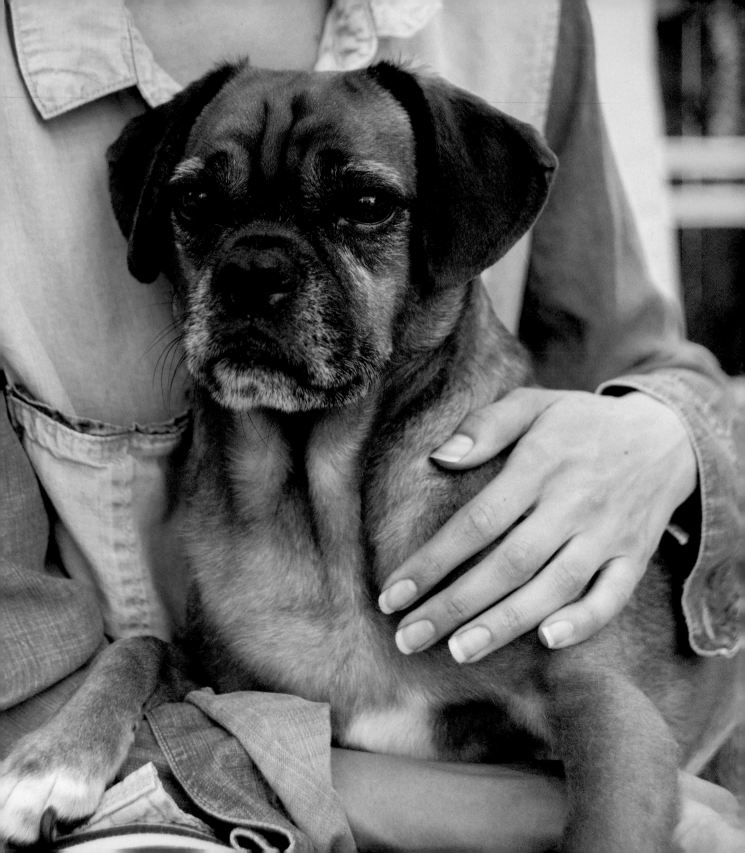

If a dog jumps in your lap, it is
because he is fond of you; but if
a cat does the same thing, it is
because your lap is warmer.

ALFRED NORTH WHITEHEAD

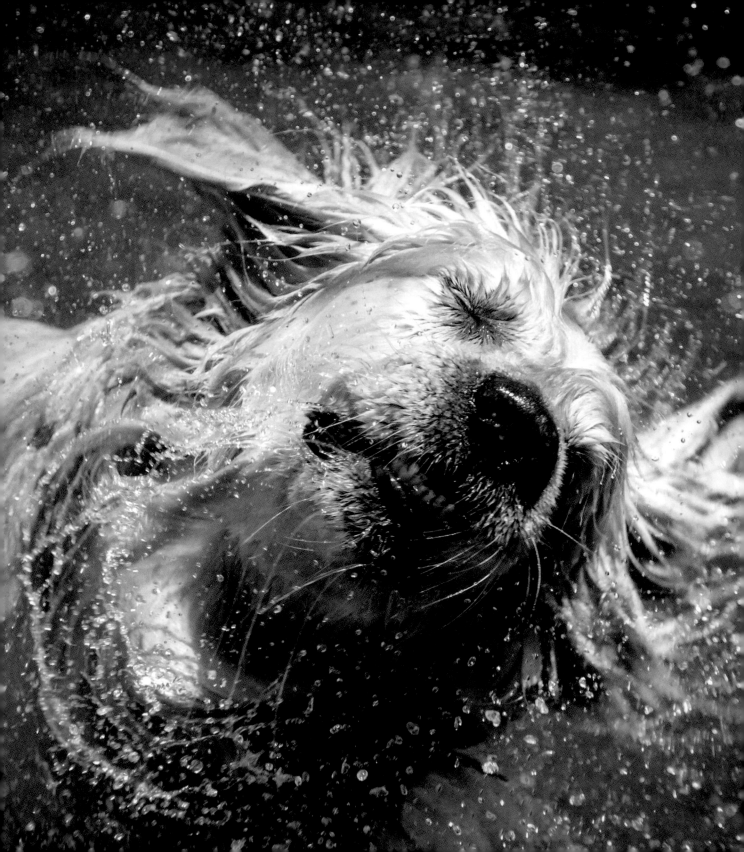

Never stand between a dog
and the hydrant.

JOHN PEERS

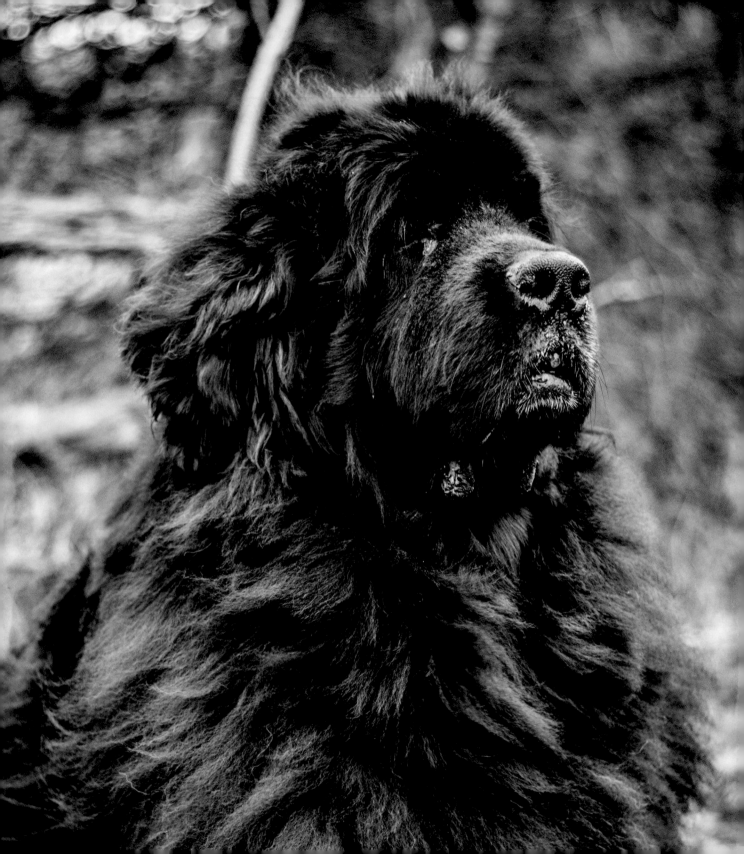

The biggest dog has been a pup.

JOAQUIN MILLER

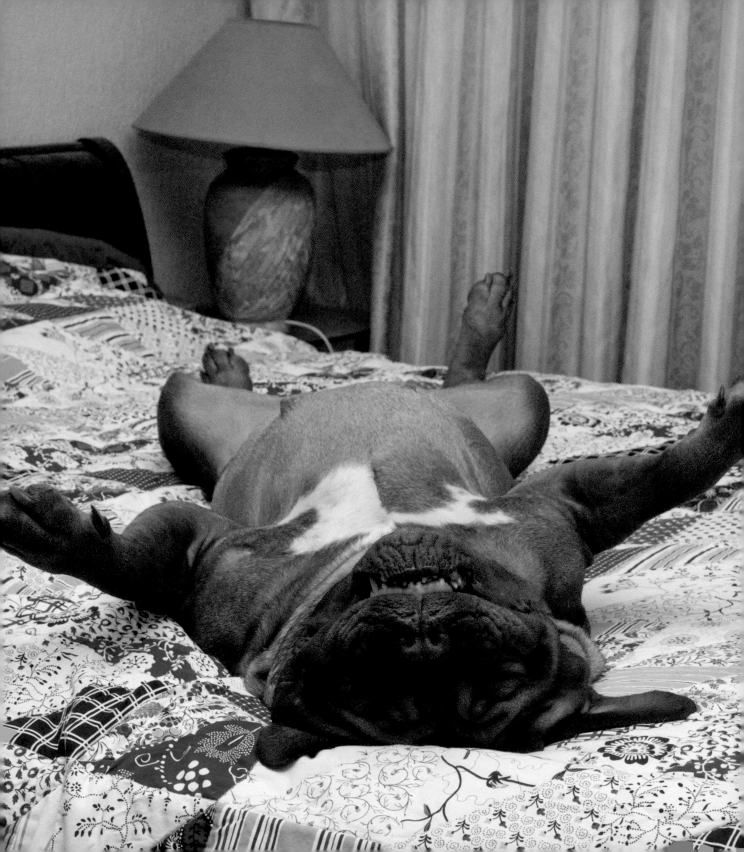

Like a dog, he hunts in dreams.

ALFRED, LORD TENNYSON

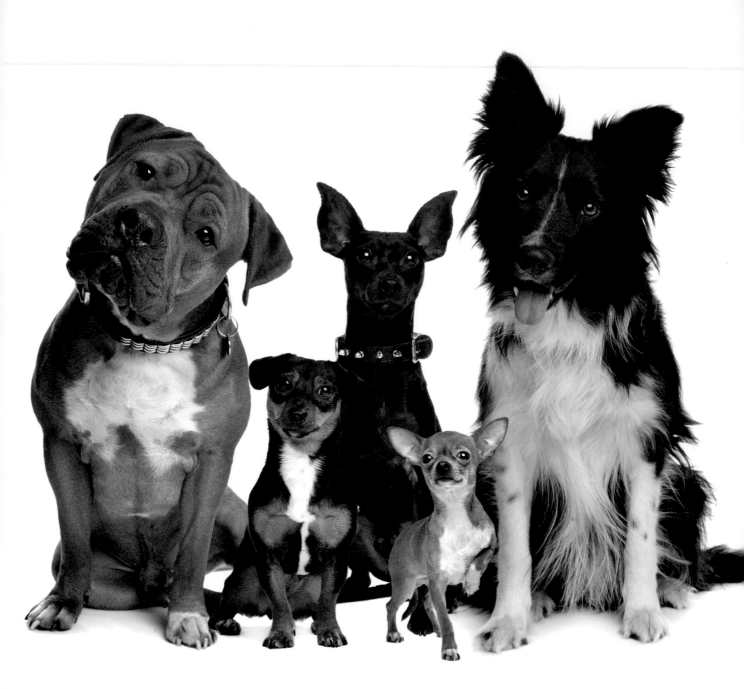

Rambunctious, rumbustious,
delinquent dogs become
angelic when sitting.

DR IAN DUNBAR

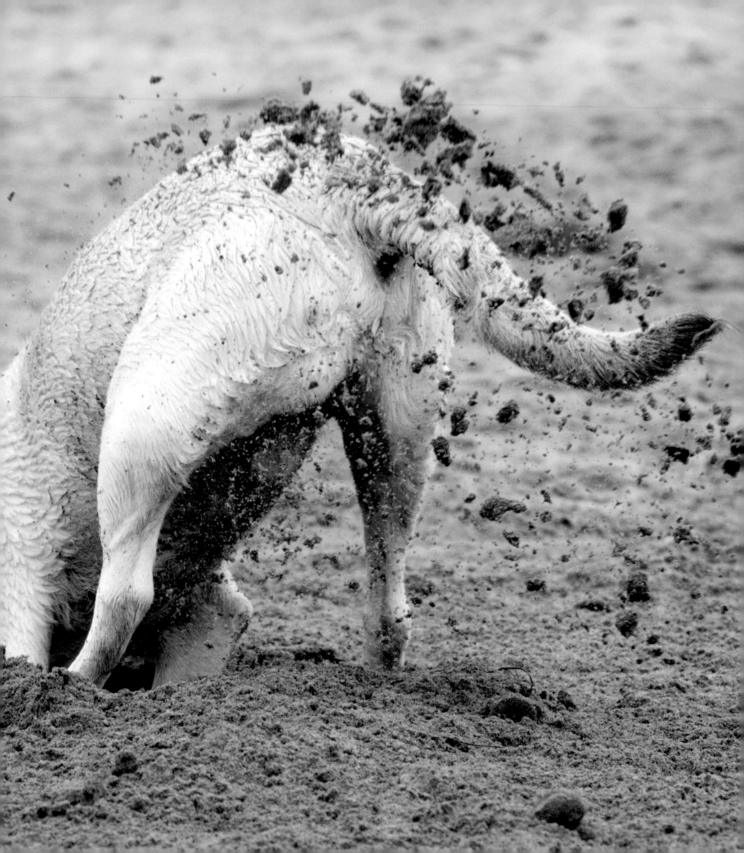

A dog wags its tail with its heart.

MARTIN BUXBAUM

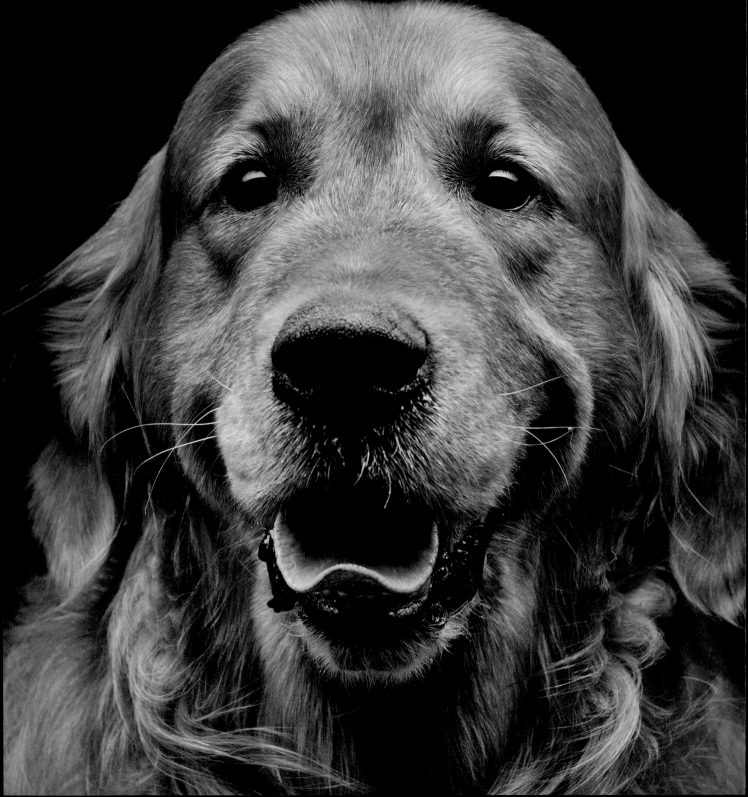

The average dog is a nicer person
than the average person.

ANDREW A. ROONEY

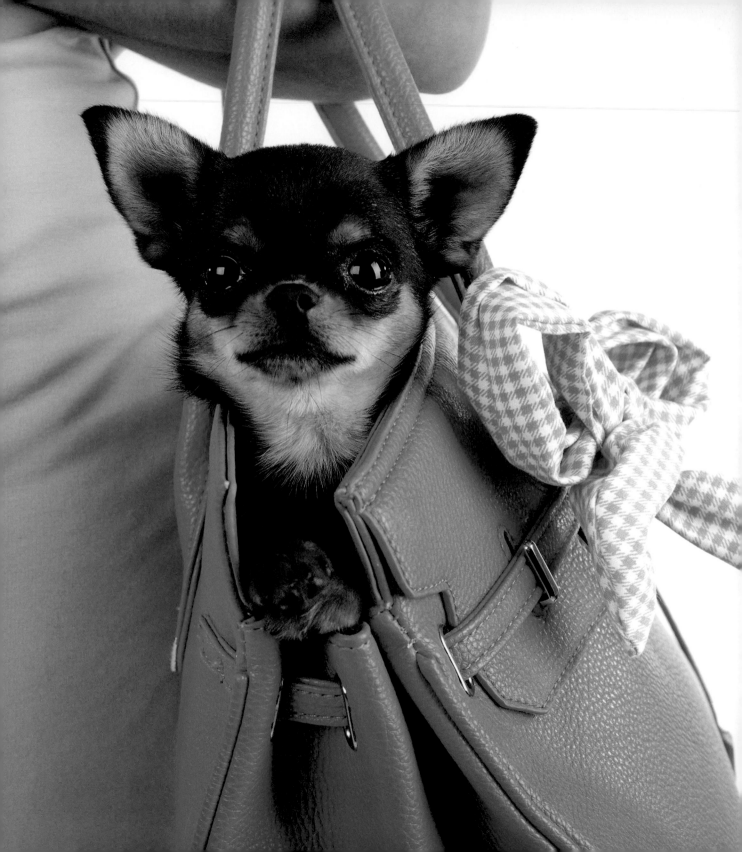

I am I because my little
dog knows me.

GERTRUDE STEIN

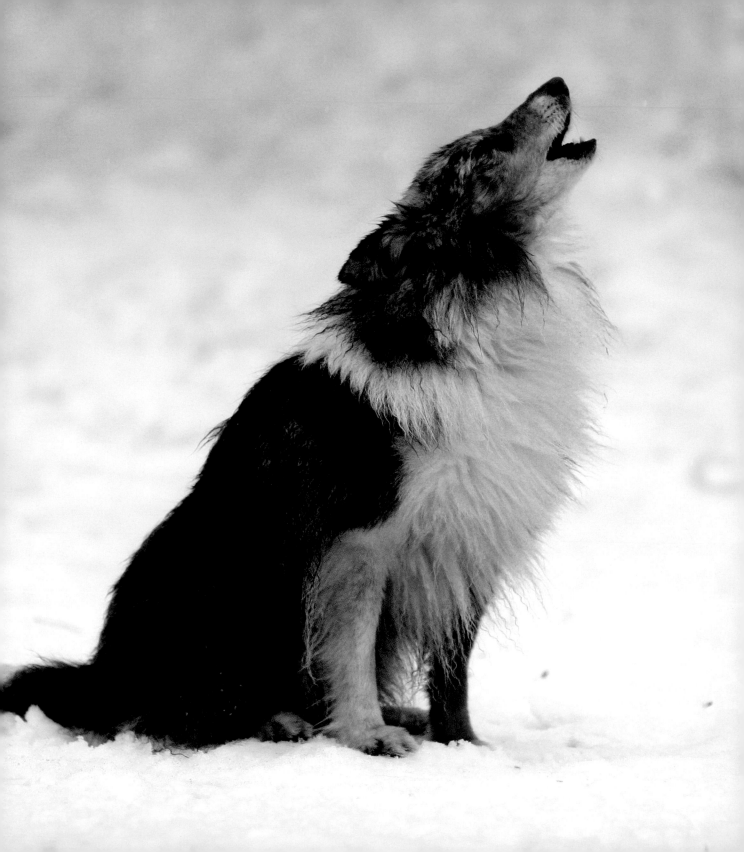

The dog is a religious animal.
In his savage state he worships the
moon and the lights that float upon
the waters. These are his gods to
whom he appeals at night with
his long-drawn howls.

ANATOLE FRANCE

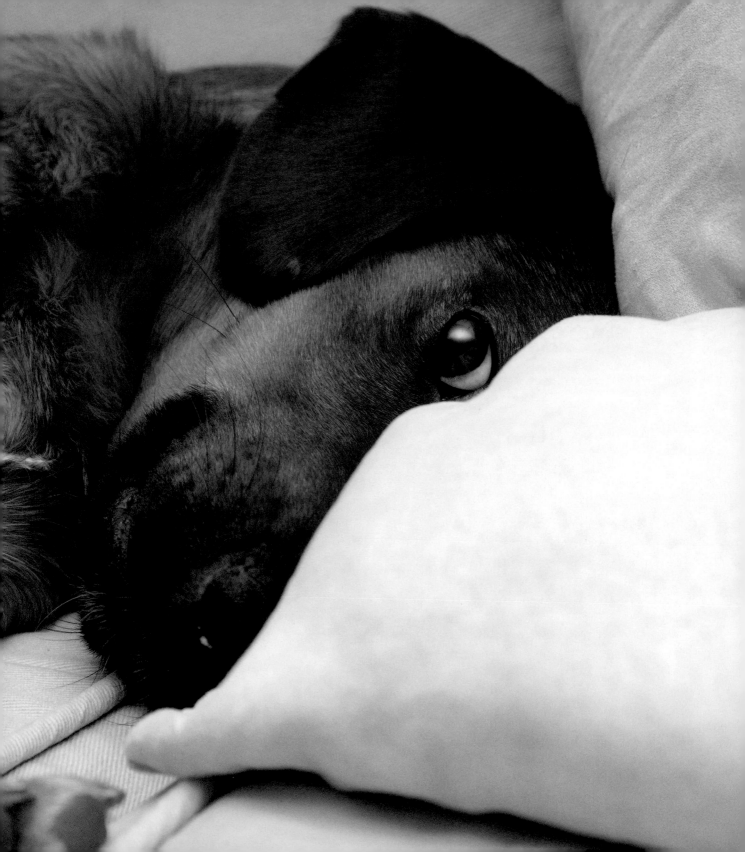

Dogs are wise. They crawl away into a quiet corner and lick their wounds and do not rejoin the world until they are whole once more.

AGATHA CHRISTIE

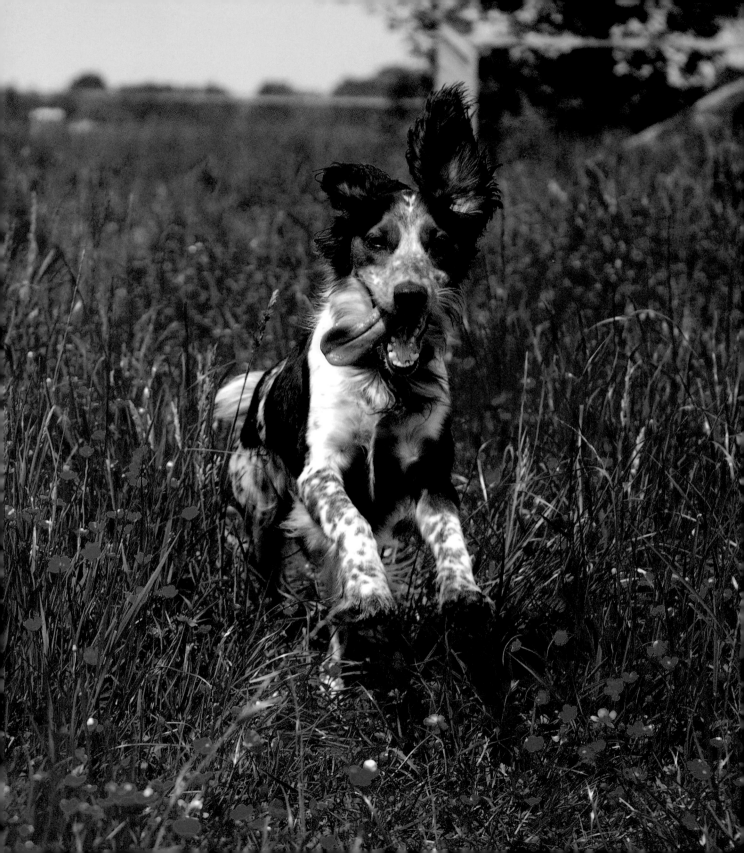

The better I get to know men, the
more I find myself loving dogs.

CHARLES DE GAULLE

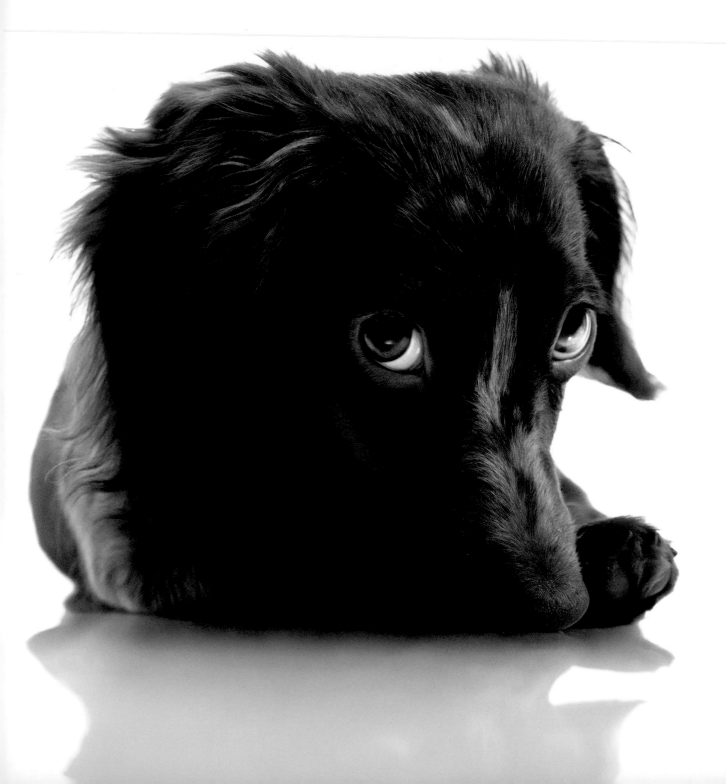

Dogs are better than human beings because they know but do not tell.

EMILY DICKINSON

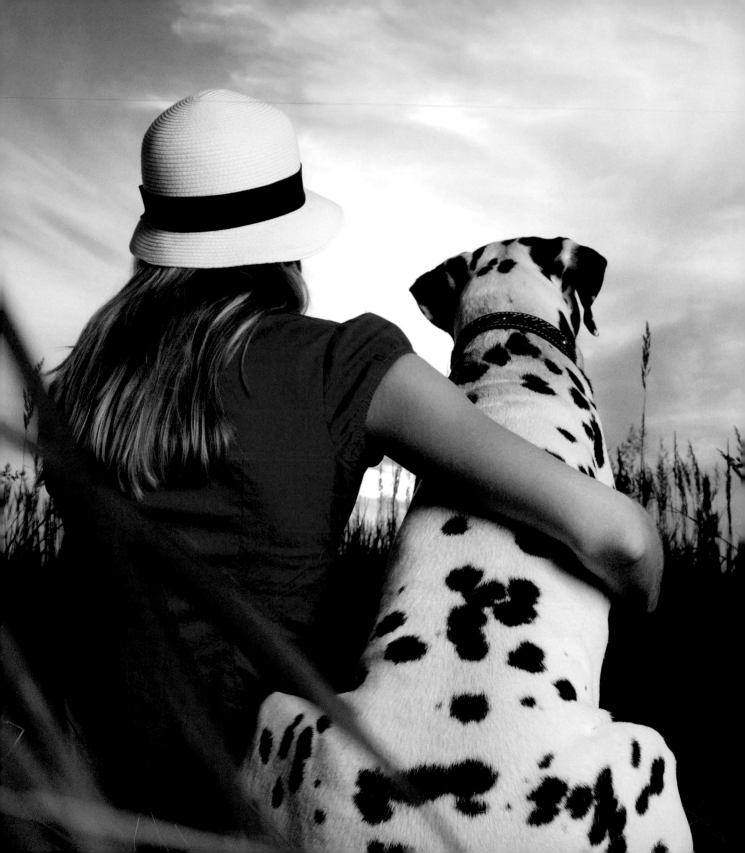

Dogs' lives are too short.
Their own fault, really.

AGNES SLIGH TURNBULL

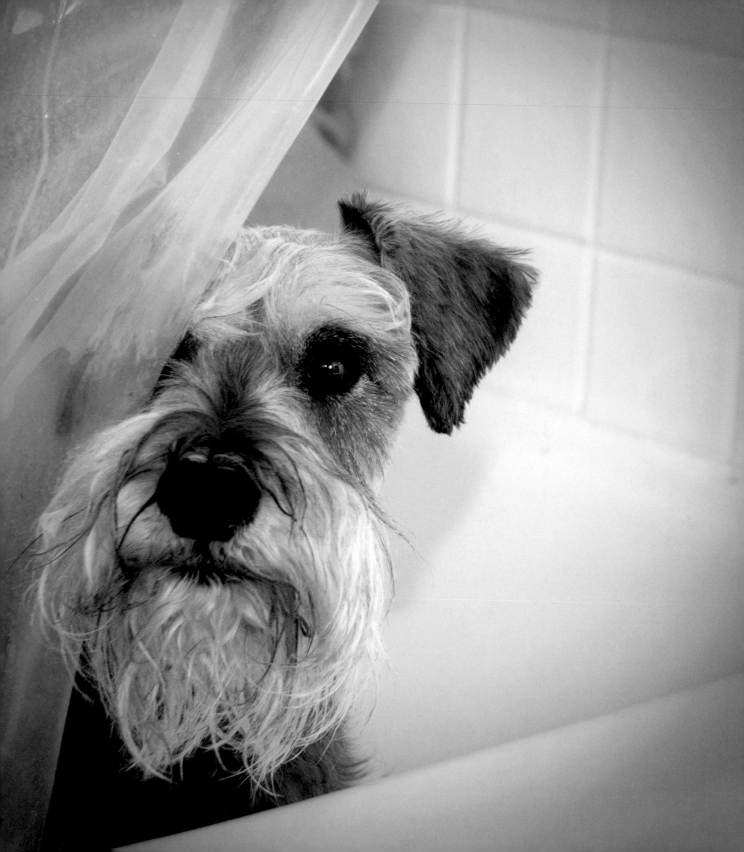

Dogs never bite me.
Just humans.

MARILYN MONROE

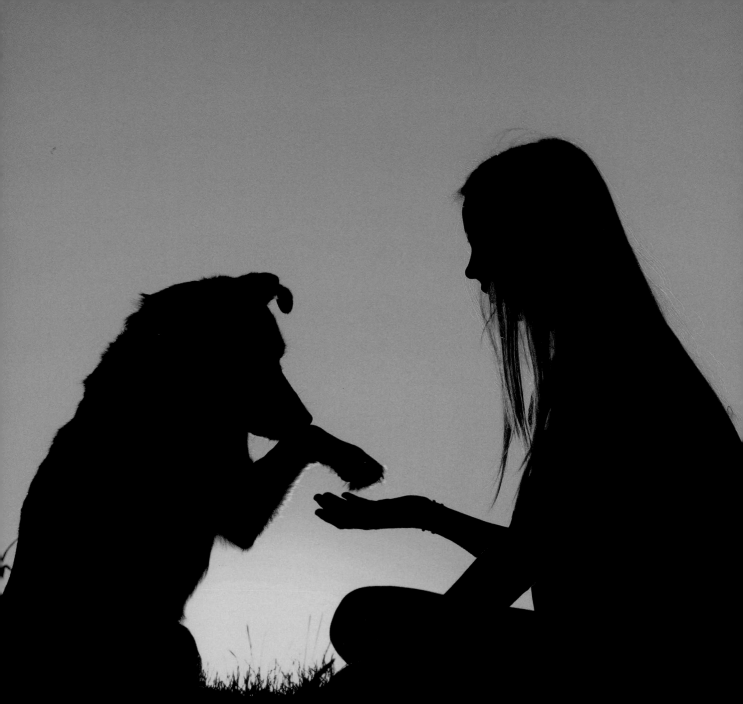

In order to really enjoy a dog,
one doesn't merely try to train him
to be semi-human. The point of it
is to open oneself to the possibility
of becoming partly a dog.

EDWARD HOAGLAND

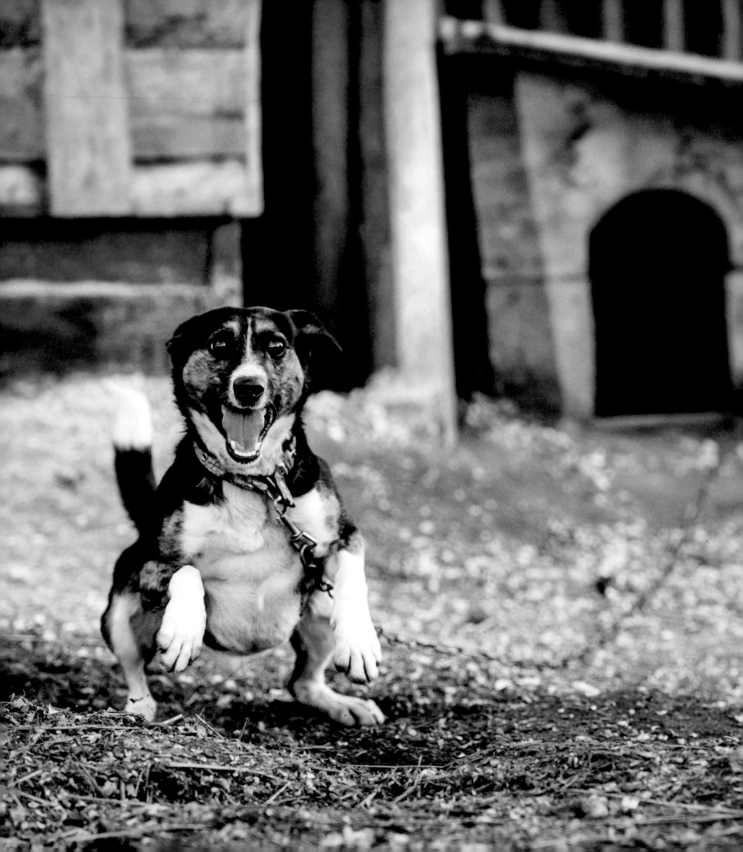

The ideal dog food would be a ration that tastes like a postman.

UNKNOWN

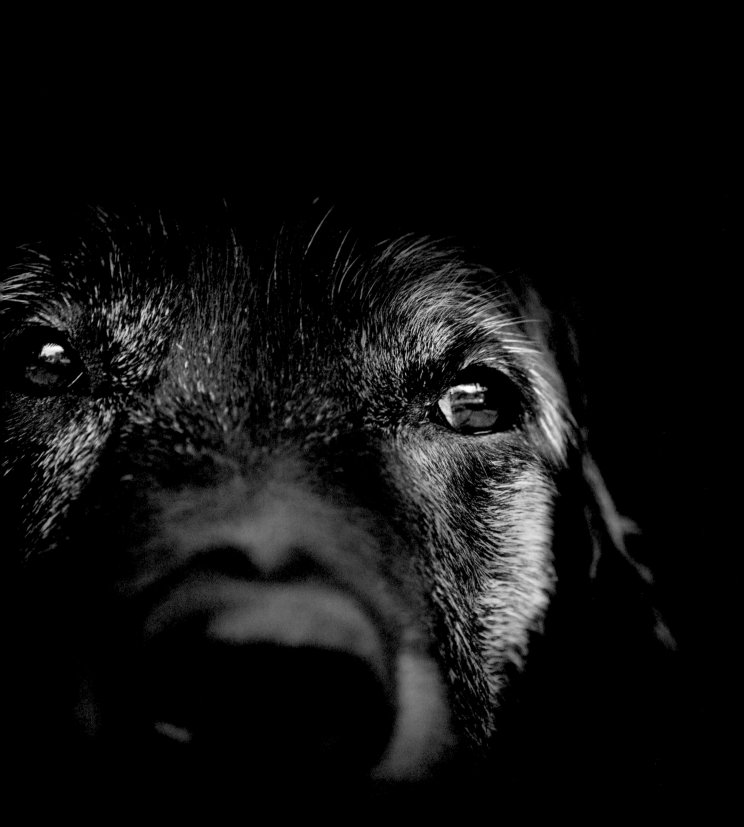

Old dogs, like old shoes, are comfortable. They might be a bit out of shape and a little worn around the edges, but they fit well.

BONNIE WILCOX

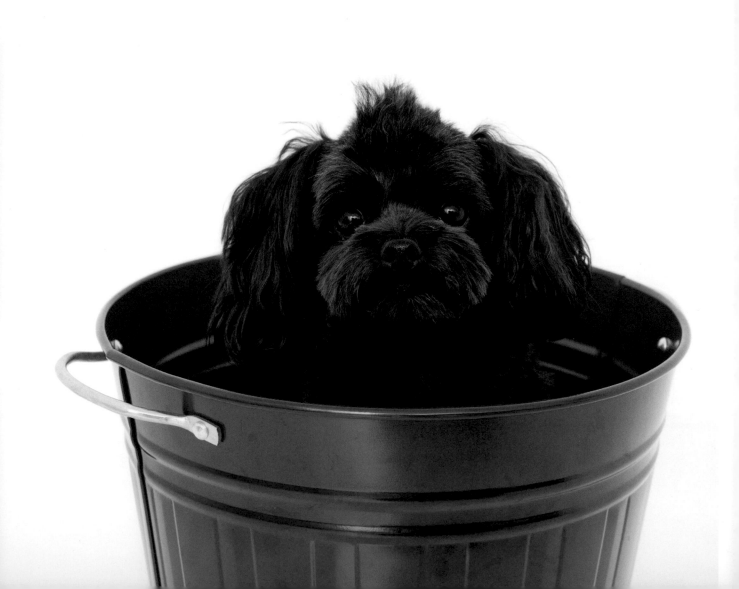

Even the tiniest poodle is
lionhearted, ready to do anything
to defend home, master,
and mistress.

LOUIS SABIN

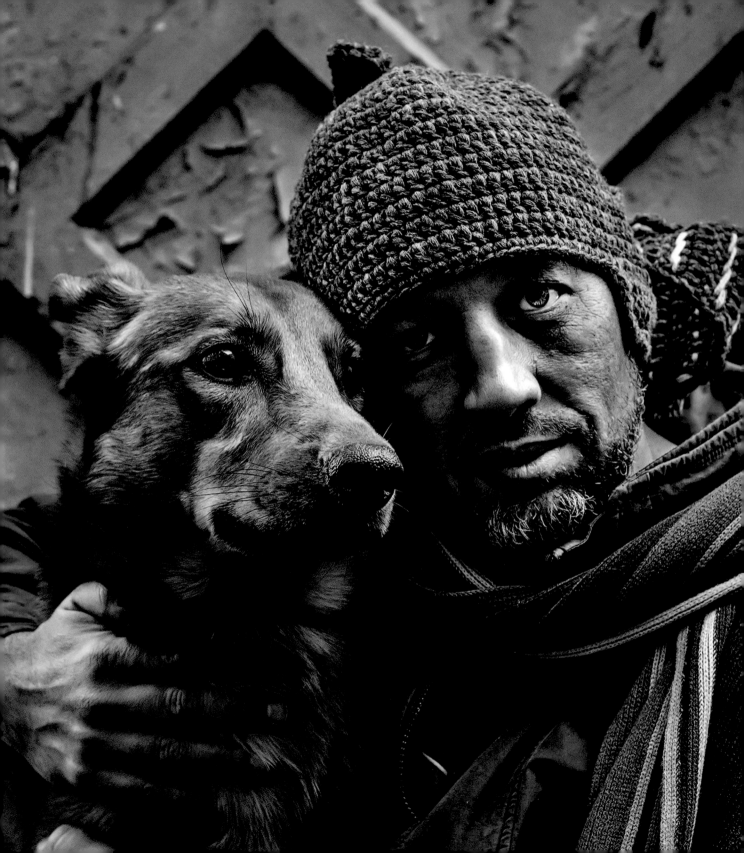

I have found that when you are deeply troubled, there are things you get from the silent devoted companionship of a dog that you can get from no other source.

DORIS DAY

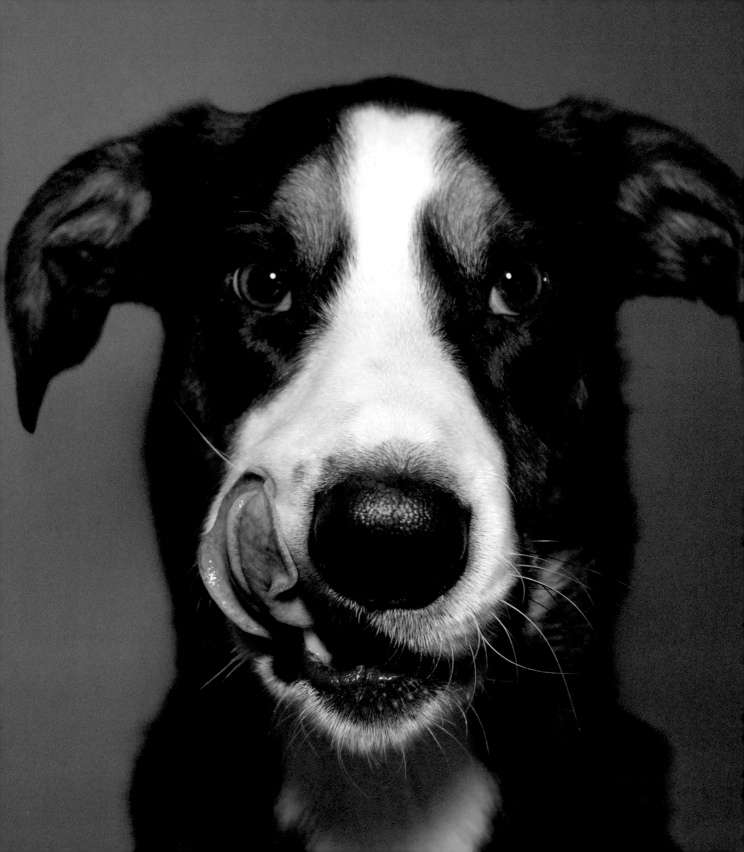

A well-trained dog will make no attempt to share your lunch. He will just make you feel so guilty that you cannot enjoy it.

HELEN THOMSON

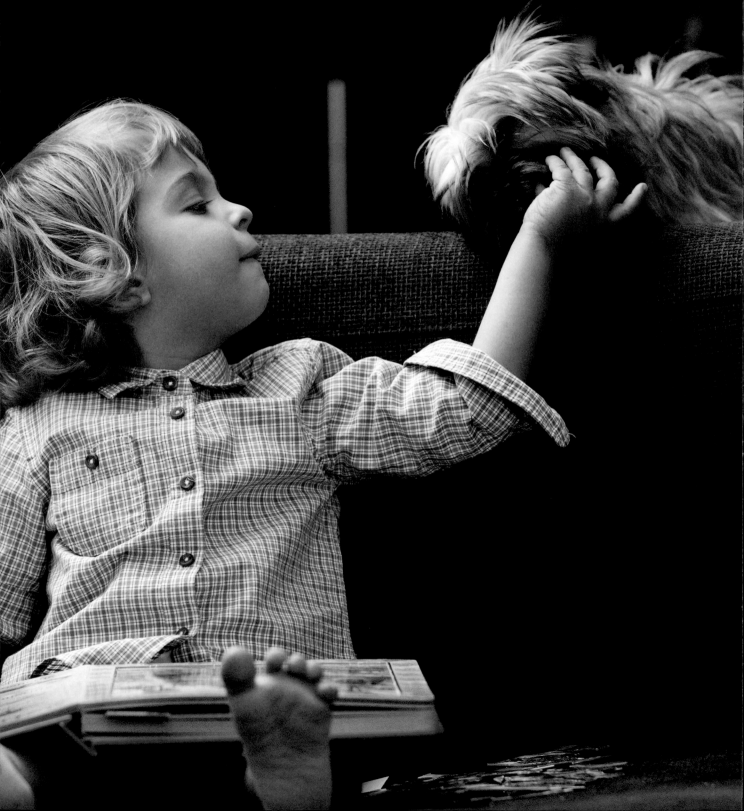

Histories are more full of examples
of the fidelity of dogs than of friends.

ALEXANDER POPE

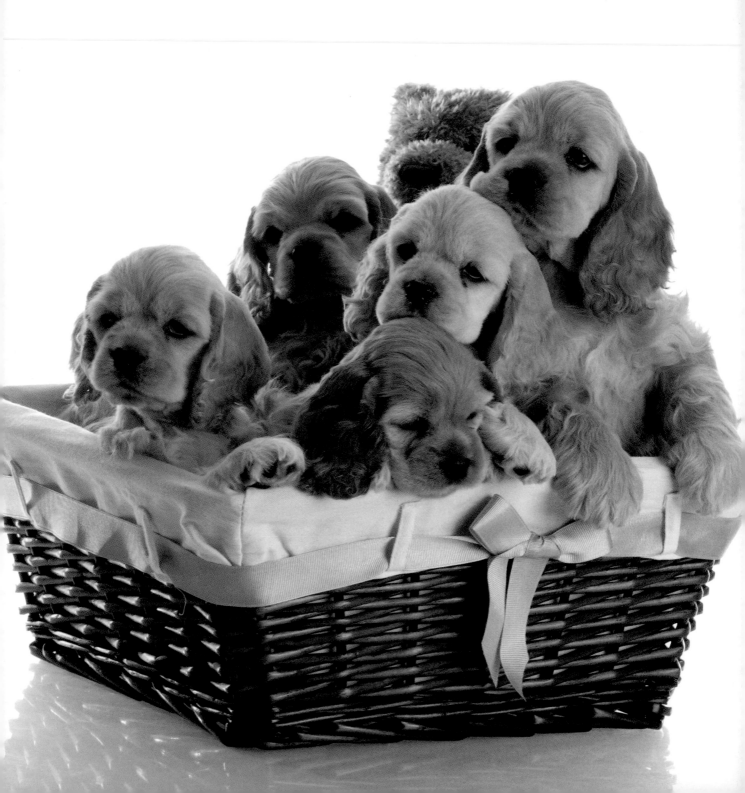

Whoever said you can't buy
happiness forgot little puppies.

GENE HILL

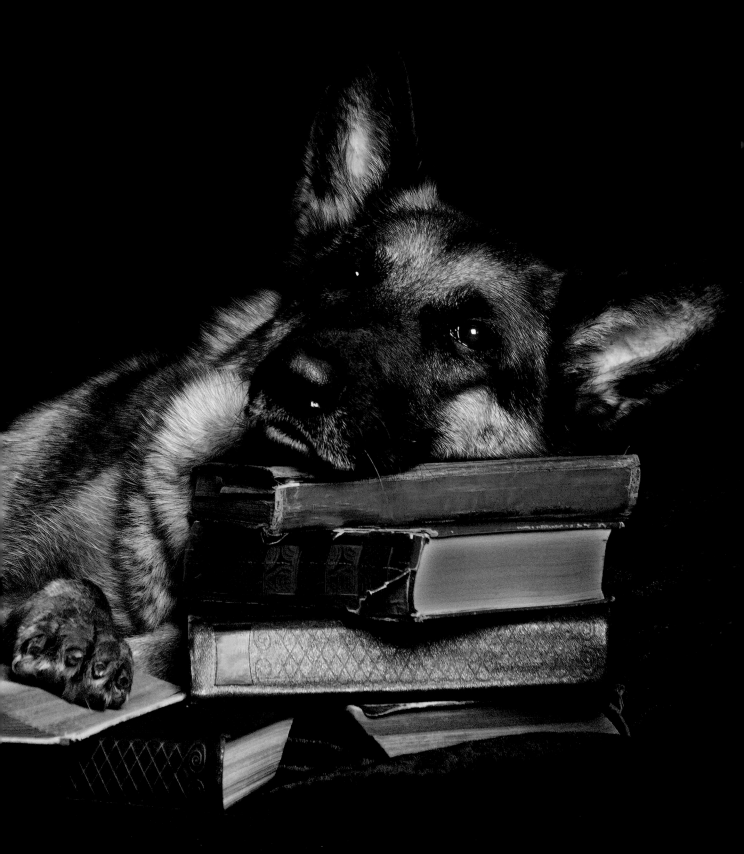

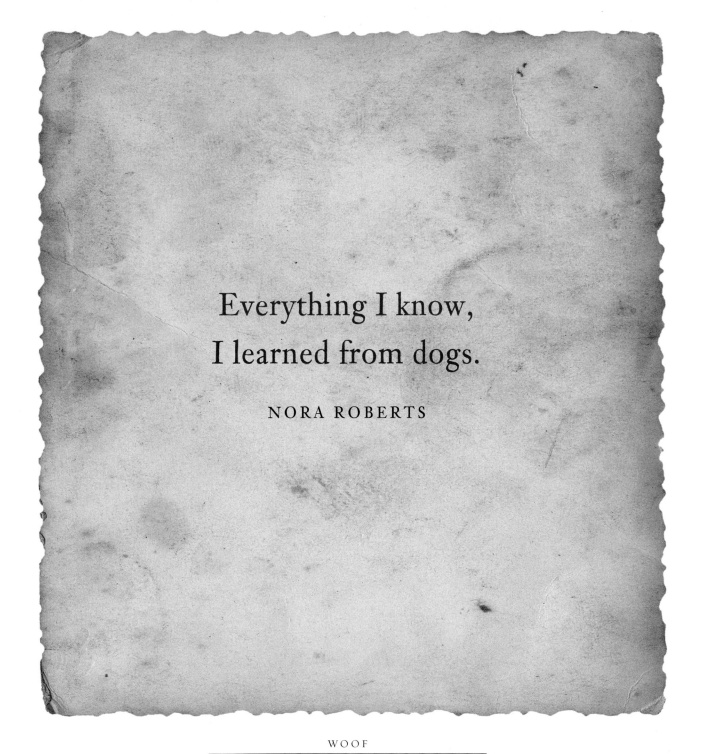

Everything I know,
I learned from dogs.

NORA ROBERTS

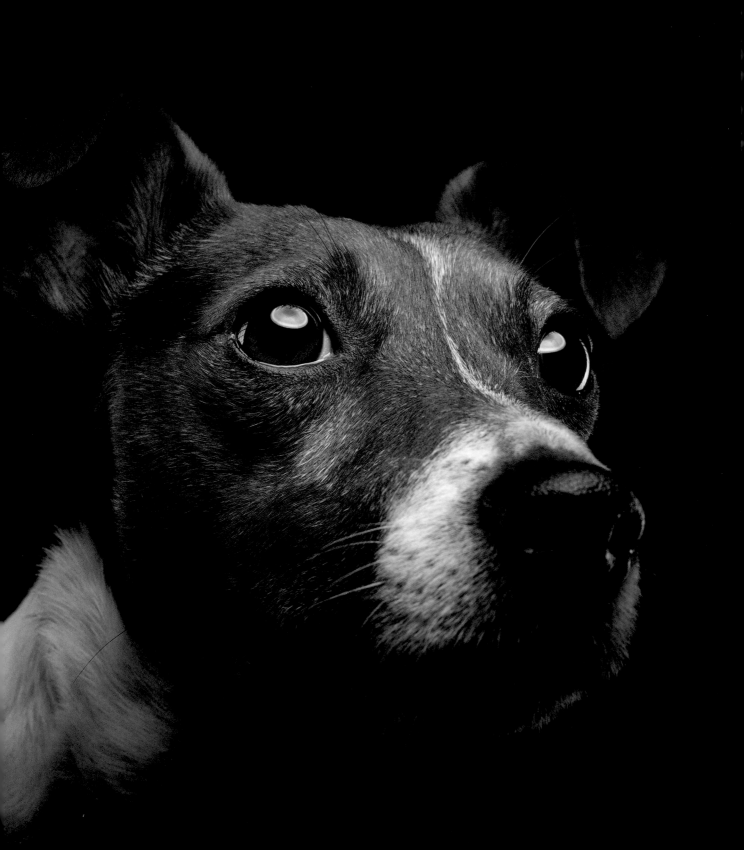

Outside of a dog, a book is
man's best friend. Inside of a dog,
it's too dark to read.

GROUCHO MARX

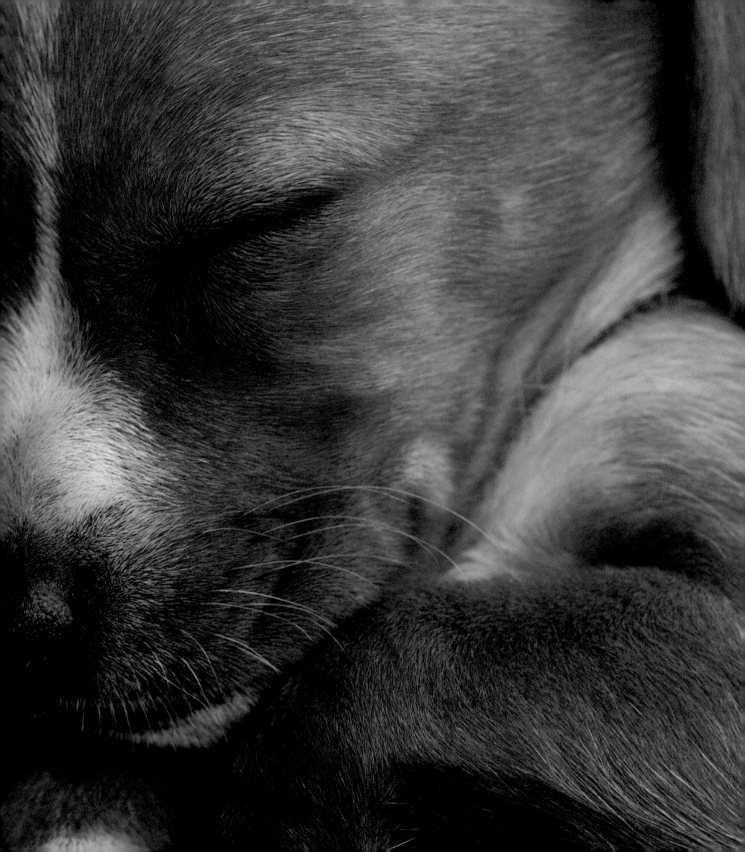

The gift which I am sending
you is called a dog, and is in fact
the most precious and valuable
possession of mankind.

THEODORUS GAZA

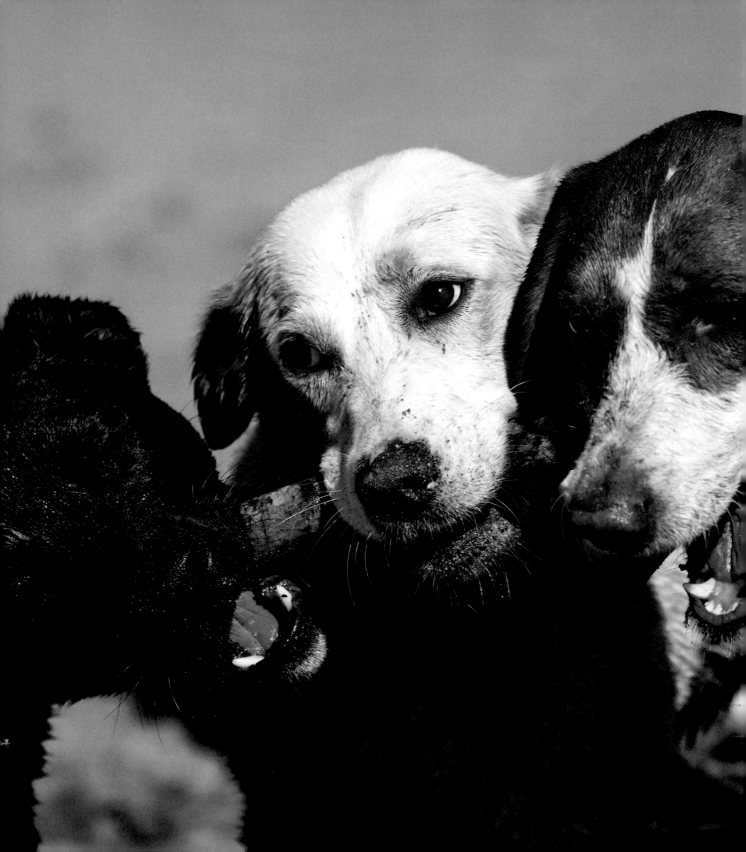

Every dog may have his day,
but it's the puppies that have
the weekends.

UNKNOWN

Also by Exisle Publishing ...

Every Dog Has Its Day

A thousand things you didn't know about man's best friend

MAX CRYER

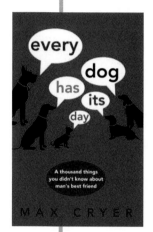

Why has Fido become a generic term for all dogs? How did dogs help to roast a haunch of venison? Why did hundreds of people collect dog faeces — and sell it? Dogs never eat other dogs, so why is it a dog-eat-dog world? Did any dogs survive the *Titanic*? Do mad dogs really go out in the midday sun? And exactly why are the 'dog's bollocks' the best?

This is a splendid collection of historical facts and eccentricities of language that will delight all dog-lovers and anyone with a morsel of interest in the world around them. *Every Dog Has Its Day* pays homage to man's best friend, telling the stories of famous dogs in history, tracing the origins of some of our favourite breeds, showing how dogs have become a significant part of our language, and describing the amazing range of activities in which dogs are involved. Written with Max Cryer's characteristic light touch and sense of humour, every page contains unexpected facts and fascinating stories. This book truly is a delight from beginning to end.

ISBN 978 1 921966 28 6

MEOW

A book of happiness for cat lovers

ANOUSKA JONES

Cats have a way of walking into our lives and making themselves right at home. No cat lover can imagine life without a feline presence — even if it is only as fleeting as the occasional conversation with a neighbourhood stray.

Meow: A book of happiness for cat lovers is a compendium of delightful quotes that capture the essence of this fascination. Some are by famous people (Mark Twain, Jean Cocteau, Ernest Hemingway), others not; some are philosophical, others light-hearted — all are memorable.

Beautifully designed and featuring high-quality photography, this companion volume to *Woof* is a collection of quotes to treasure.

ISBN 978 1 925335 08 8

First published 2016

Exisle Publishing Pty Ltd
'Moonrising', Narone Creek Road, Wollombi, NSW 2325, Australia
P.O. Box 60–490, Titirangi, Auckland 0642, New Zealand
www.exislepublishing.com

A CiP record for this book is available from the National Library of Australia.

ISBN 978 1 925335 09 5

Designed by Big Cat Design
Typeset in Archetype 24 on 36pt
Photographs courtesy of Shutterstock
Printed in China

This book uses paper sourced under ISO 14001 guidelines from well-managed forests and other controlled sources.

2 4 6 8 10 9 7 5 3 1

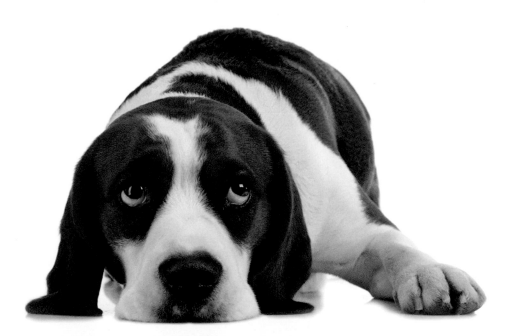